IMAGES
of America

ALLENTOWN

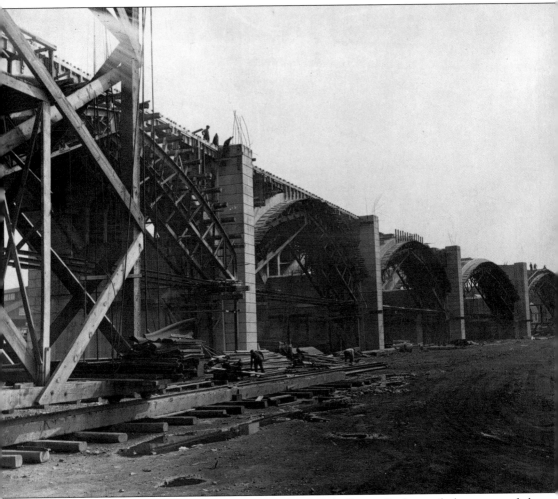

Allentown has two great structural icons: the Eighth Street Bridge and the tower of the Pennsylvania Power and Light Company (PP&L). Shown here is falsework in place as the great concrete bridge that spans the wide valley of the Little Lehigh Creek is being constructed.

IMAGES
of America

ALLENTOWN

Ann Bartholomew and Carol M. Front

ARCADIA

First published 2002
Reprinted 2002, 2003, 2004

Published by Arcadia Publishing,
Charleston SC, Chicago IL, Portsmouth NH, San Francisco CA

Printed in Great Britain

Library of Congress Catalog Card Number: 2001099226

For all general information, contact Arcadia Publishing:
Telephone 843-853-2070
Fax 843-853-0044
E-mail sales@arcadiapublishing.com
For customer service and orders:
Toll-free 1-888-313-2665

Visit us on the Internet at www.arcadiapublishing.com

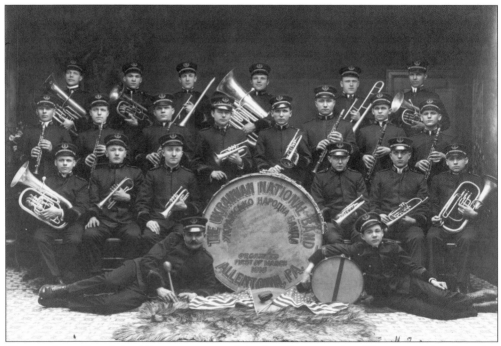

The number of bands in Allentown was nothing less than amazing. There was a band to play for every occasion, from the Allentown Band, the oldest civilian concert band in the United States, to the Juvenile Band and others for young instrumentalists. There were bands composed of employees of businesses and industries, and ethnic bands proliferated as more and more people came from different homelands to the city to find work in the late 19th century. The Ukrainian National Band, one of a number of bands formed by immigrant groups and their descendants, is shown soon after it was organized in 1916.

CONTENTS

ACKNOWLEDGMENTS

The authors of this book owe the utmost gratitude to collector and entrepreneur Raymond E. Holland for allowing the use of his materials for this book. He is an avid collector of northeastern Pennsylvania history, and the photographs included in *Allentown* are all from his extraordinary Pennsylvania history collection. Holland's initial interest in regional history was sparked by visits to Mauch Chunk, Pennsylvania, and his subsequent research into the town's beginnings, including the discovery of anthracite nearby and its importance in the birth of the industrial revolution. What began 10 years ago as a passion for one small but important town has evolved into one of the most comprehensive Pennsylvania collections anywhere. The Raymond E. Holland Regional and Industrial History Collection includes thousands of photographs, books, town directories, prints, china, paintings, and other ephemera. Holland's vision of collecting is both insightful and generous. The collection has always been available for exhibition in Pennsylvania communities and museums, as well as for research. Holland believes that no one person can own history nor hide it away. This book is an example of his generosity.

Many others have contributed their knowledge, talent, and support to this project, including Wally Ely, Bob Ott, David Bausch, Bernie Stinner, Jim Musselman, Charlie Smith, Ray Mulligan (all affectionately known as "the Geezers"), Glenn Koch, Craig Bartholomew, John Heyl, Ken Swartley, Ron and Linda Chmielewski, Ray Imlay, Bradley Schaeffer, Dave Madary, Kurt Zwikl, Doug Peters, and Charles Canning.

I would like to thank my coauthor and collaborator, Ann Bartholomew, whose incredible knowledge, drive, and ability as a writer made this book possible.

Carol M. Front, Curator, Raymond E. Holland Regional and Industrial Collection

INTRODUCTION

In 1762, a wealthy Philadelphian, William Allen, set aside several hundred acres of family-owned property at a picturesque location where the Little Lehigh and Jordan Creeks enter the Lehigh River. European settlers, primarily from Germany, were then moving into the area in large numbers to establish farms, and several townships had already been founded. The new community, named Northampton until 1838, was to be a market and tradesmen's town for western Northampton County, a commercial center for the growing population in the surrounding area. When Lehigh County was carved out of Northampton County in 1812, Allentown became the county seat and began its long prosperity.

For many years, Allentown was the third city of the Lehigh Valley, after Easton and Bethlehem. Not until the second part of the 19th century did the "Queen City" of the Lehigh Valley—a name of unknown origin—exceed the other two in population. The phenomenal growth of heavy industry, precipitated by the production of iron and iron products, changed Allentown from a comfortable county seat and market town into a major center of commerce with a multitude of iron-related industries. Furnaces, rolling mills, and foundries lined the Lehigh River from Catasauqua to Salisbury Township, producing iron and iron products. Waves of people moved from farms into the city to work. The heavy industries that were first located along the Lehigh River, and then along the railroad lines as well, began to attract immigrants and workers from other parts of Pennsylvania and the United States. The First and Sixth Wards between the Lehigh River and Jordan Creek provided homes for families of many nationalities and various religions. In the decade between 1860 and 1870, the population of Allentown increased from a little more than 8,000 to almost 13,000. During that decade of rapid growth, in 1867, the borough of Allentown became a city.

By the time photographers began to examine their communities through their lenses, Allentown was a thriving city—but not for long. Photographic images of the time do not show what was to come: the hard times experienced during the Panic of 1873 and the major depression that followed. The abrupt cessation of railroad expansion that year affected every community that produced iron, and Allentown, which had become heavily dependent on iron, felt the blow deeply. By the end of the decade, the town fathers (otherwise known as the Board of Trade) had begun a search for an industry that could employ the many who had lost their jobs. At the same time, managers of the silk industry in Paterson, New Jersey, were looking for a place to expand where labor would be cheaper and more compliant. Within a few years, Allentown had become the second-largest silk-manufacturing center in the nation, after

Paterson. Not only was Allentown a source of labor, and a city willing to put up money for development of the new industry, but the railroads that passed through Allentown—the Lehigh Valley Railroad and the Central Railroad of New Jersey—provided easy routes for products to be shipped out to major markets, and for raw materials to be brought in.

Another influx of workers, including large numbers of young women, arrived over the next decades to work in the silk mills. The iron industry revived, becoming once again a vital constituent in the increasingly diversified economic base of the city. A large furniture industry developed. Cigar making employed many people in small and large factories. A large part of the wealth of the city came from its expanding commercial sector. By the end of the 19th century, Allentown was proud to be home to well over 35,000 people.

During the 20th century, Allentown's economy became even more broadly based. The iron furnaces were blown out, but foundries and manufacturers of structural ironwork thrived. By 1916, there were as many as 28 mills producing silk goods in the city, as well as dozens of businesses that supplied equipment and other necessities for the silk mills. A variety of industries moved to the city to take advantage of its skilled workforce, contributing to the ever-increasing diversification of the city's economic base. Of the large ones, the best-known names are Mack Trucks and Western Electric. There were many others, including Traylor Engineering, whose primary business was manufacturing equipment for use in quarries and cement mills; it became a major supplier of parts for the army and navy during both world wars. The cement industry was very important in the region (portland cement was first produced successfully in the United States in nearby Coplay in the 1860s), and one of the largest companies, Lehigh Portland Cement, built its headquarters on Hamilton Street in Allentown. PPL Corporation, formerly the Pennsylvania Power and Light Company, still occupies its handsome tower building on Hamilton Street, which was considered an avant-garde structure when it was completed in 1928. Air Products and Chemicals, based outside Allentown, employs many city residents and has been a significant player in the city's cultural and educational life.

While industries rose and declined, one thing remained constant until recent years. From the late 1800s until the 1970s, Allentown was the premier shopping area for miles around. A shopping excursion by train to Philadelphia may have been exciting, especially at Christmastime, but Allentown had department stores on Hamilton Street that could compete with anything in Philadelphia. Hess's, Leh's, and Zollinger-Harned department stores catered to the fashionable and the conservative. Hess's became nationally known for its fashion shows, its spectacular flower shows, and the movie stars and other famous personalities who were invited to cut ribbons at special events. Sadly, all are out of business today.

Much of the forgotten history of Allentown can be revisited in the following pages, including the industries that are no longer here, stores that have disappeared, and the trolley cars that are possibly missed more than any other thing. Today, we have a city with more than 100,000 residents, a regional economy that remains highly diversified, and community leaders with great plans for the future. If the photograph is, as Cartier Bresson described it, "the decisive moment," the authors of this little book of moments hope to read a similar book 20 years from now that depicts the decisive moments of today.

One
RAILS, RIBBONS, KILOWATTS, AND BEER

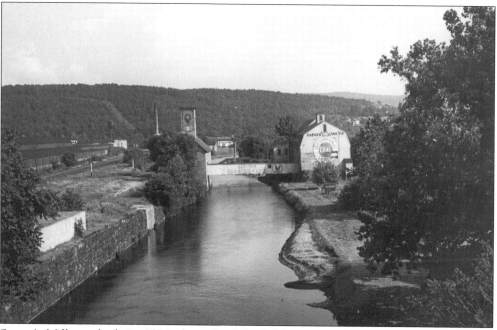

Saeger's Mill was built in 1828 along the Lehigh Navigation the same year the canal was completed. It used waterpower purchased from the Lehigh Coal and Navigation Company, the owners of the canal. In 1882, the mill (originally a gristmill) was modernized and rollers were installed to make finer flour. The mill straddled the canal a short distance below the dam on the Lehigh River. The covered bridge allowed the company to use both banks of the canal. An Old Company's Lehigh sign, advertising the anthracite for which the canal had been developed, is on the side of the building.

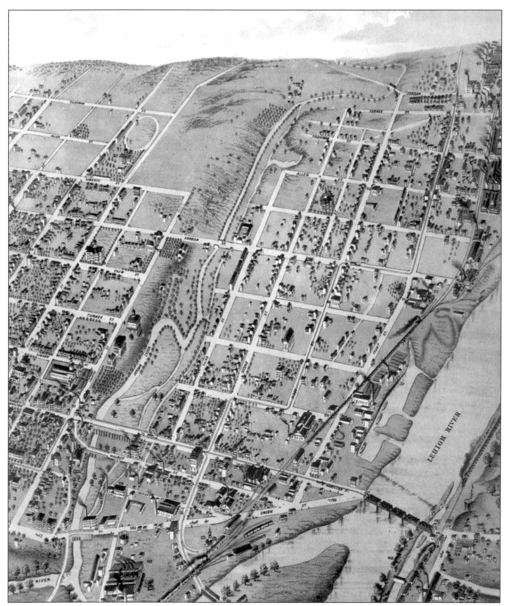

The industrialized section of Allentown developed first along the Lehigh River, as can be seen in this section of the 1873 "Bird's Eye View" of the city. The Allentown Iron Company, a merchant pig-iron producer, is at the upper right with the Allentown Rolling Mill Company just below. The river and canal are on the far right, with the tracks of the Central Railroad of New Jersey running parallel to the canal on the east bank. The tracks of the Lehigh Valley Railroad, on the west side of the river, ran through furnaces and rolling mills before swinging into the city. In the early years, the principal commodities carried on the railroads, as on the canal, were anthracite, iron ore, and iron products.

Allentown became a major iron-producing center in the mid-19th century. The Allentown Rolling Mill Company absorbed several adjacent companies to become the most significant iron company in the city, employing more people and turning out more products than any other. The output of its furnaces was used in its own mills for the manufacture of finished and semifinished products, many for railroads. Its furnaces, mills, and machine shops turned out rolled "T" and street rails, merchant bars, angles, spikes, bolts, nuts, axles, machinery, bridge work, mine cars, and flatcars.

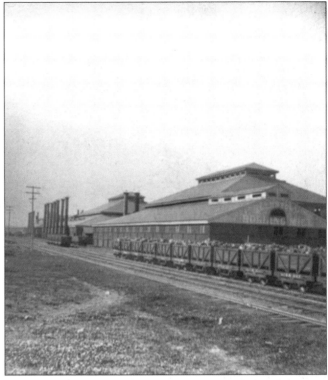

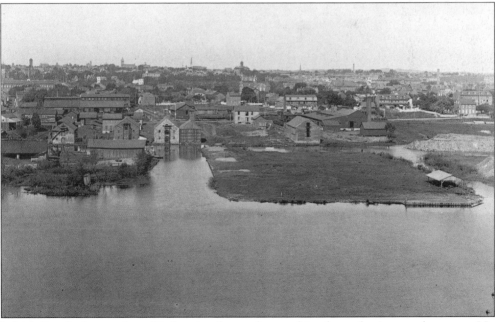

Lehigh Port had a number of industries clustered around its channels. Among them were J.L. Hoffman's large sawmill and lumberyard, a gristmill, and the Albright and Son Tube Works. This part of town was named "Lehigh Port" because it was the city's port on the Lehigh River. Canal boats were poled across to serve its businesses. It is the section now identified as "Lehigh Landing" in the Delaware-Lehigh National Heritage Corridor.

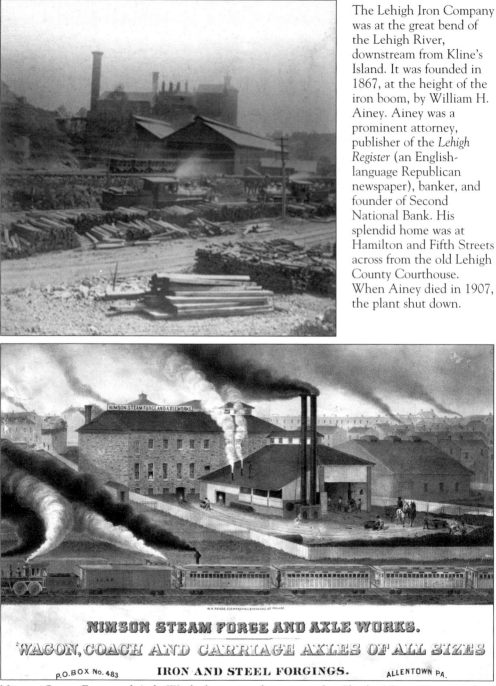

The Lehigh Iron Company was at the great bend of the Lehigh River, downstream from Kline's Island. It was founded in 1867, at the height of the iron boom, by William H. Ainey. Ainey was a prominent attorney, publisher of the *Lehigh Register* (an English-language Republican newspaper), banker, and founder of Second National Bank. His splendid home was at Hamilton and Fifth Streets across from the old Lehigh County Courthouse. When Ainey died in 1907, the plant shut down.

NIMSON STEAM FORGE AND AXLE WORKS.

WAGON, COACH AND CARRIAGE AXLES OF ALL SIZES

P.O. BOX No. 483 **IRON AND STEEL FORGINGS.** ALLENTOWN PA.

Nimson Steam Forge and Axle Works began production, under Charles Nimson's ownership, in the 1860s. Nimson was superintendent of the Roberts Iron Company from 1863 and remained superintendent when the company merged with the Allentown Rolling Mill Company, which was located downstream from the present Tilghman Street Bridge. Nimson pursued numerous business ventures, managing furnaces, forges, rolling mills, and mining operations in addition to serving as superintendent of the Allentown Rolling Mills.

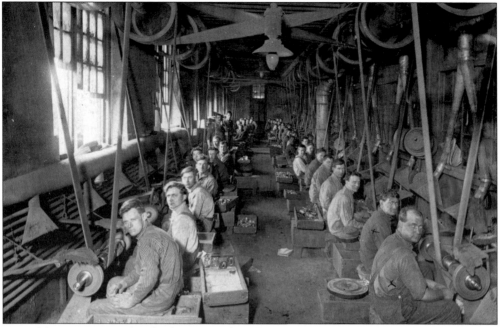

One of the many iron-related industries in the Allentown area was Dent Hardware in Fullerton, which manufactured iron and brass items such as refrigerator trimmings, iron toys, and specialty hardware items. The firm was founded in 1894 and rapidly developed a reputation for quality. By the early 20th century, it employed 400 people. This picture of men in the polishing room dates from 1908.

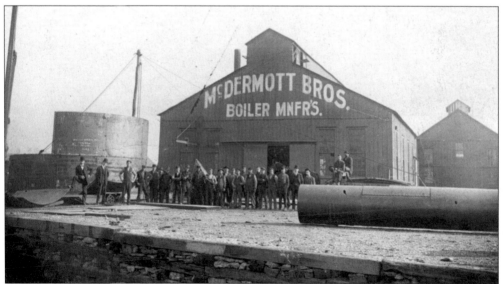

Allentown had a number of pipe foundries and boiler works, manufacturing items for steam-powered industrial plants, railroads, and steamships, in its industrial section near the Lehigh River. McDermott Brothers moved to this site at Third and Washington Streets in 1900, along the tracks of the Allentown Terminal Railroad. As can be seen in this photograph by F.G. Rohrbach, some of the company's products were exceptionally large. McDermott Brothers made wrought-iron plate items such as boilers, tanks, stacks, rotary kilns, dryers, and coolers.

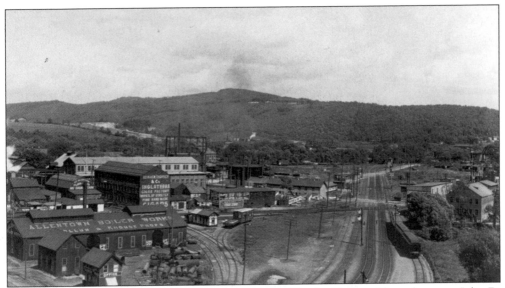

The Allentown Boiler Works was founded in 1883 by Charles Collum. He and partner John D. Knouse built this large facility at Third and Union Streets some years later to accommodate their expanding business in sheet-iron products. This well-known firm manufactured equipment used in the White House and the Military Academy at West Point, and its boilers and cement kilns were shipped not only across the United States but also to other countries such as Canada, Cuba, and the Philippines.

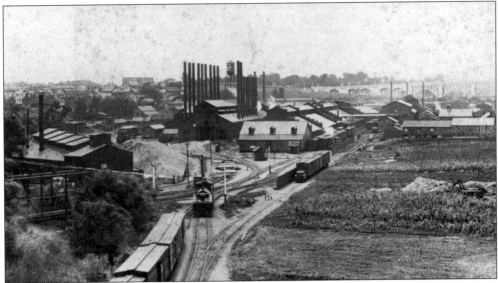

One of the largest industrial complexes in Allentown was the wire mill of the American Steel and Wire Company. The wire mill lay along the Little Lehigh Creek east of Lehigh Street. Originally built by the Iowa Barb Wire Company, which had expanded into Allentown in the mid-1880s, it became part of United States Steel when that corporation was created in 1901. By 1915, the date of this photograph, it was producing more than 100,000 tons of barbed wire, staples, and nails. It became a major producer of barbed wire for the Allies in World War I. The plant was shut down in 1943 and was razed in the late 1960s during the renewal of the blighted Little Lehigh area.

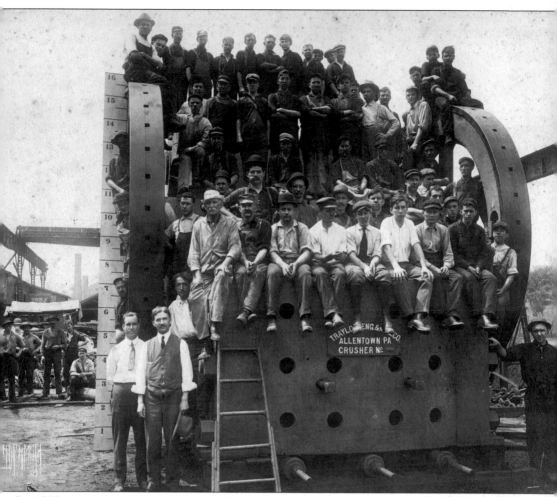

In 1902, a young mining engineer, Sam Traylor, founded the Traylor Engineering and Manufacturing Company. At first, the plant made large equipment for the mining industry, some for American industries but much for export. The outbreak of World War I provided Traylor with the incentive and opportunity to retool and expand the plant when it received a large order from the British government for shells. After the United States entered the war, the company made marine engines and boilers and other small but essential parts. During World War II, the company again became a vital defense contractor. In 1959, Traylor became a division of the Fuller Company of Catasauqua. The company still makes mining and crushing equipment at the same location.

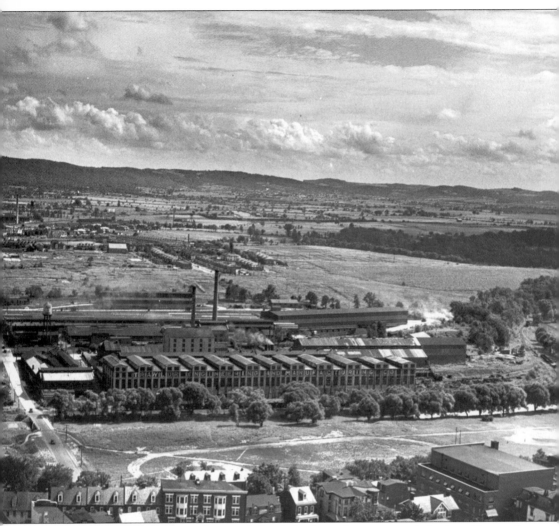

The Little Lehigh Creek can be seen behind the line of trees as it winds along the northern edge of the Traylor Engineering and Manufacturing Company property. Part of the first plant of Mack Trucks is behind it, and South Allentown is in the background. The Mack brothers, Jack and Gus, moved their Mack Brothers Motor Car Company to Allentown from Brooklyn in 1905, taking over the foundry, forge, and machine shops of the former Weaver-Hirsh Company on South Tenth Street. The space was used for production and experimentation. By the outbreak of war in Europe in 1914, the company's trucks had developed a reputation for being sturdy and reliable. The nickname "Bulldog" was given to the Mack AC five- and seven-ton trucks used during the war. Large numbers of these and other trucks were made in the Allentown plant. Mack Trucks became part of the International Motors Corporation in late 1911. The company built a number of plants in the Allentown area.

When the Adelaide silk mill opened in 1881, the city fathers had high hopes for the silk trade. Silk, with its many ancillary businesses, soon became the largest industry in the city and remained so until well into the 20th century. By 1914, there were 26 mills in Allentown. In 1928, when rayon was being introduced in some of the mills, 8,250 people were employed in the production of textiles and textile products at Allentown's 85 textile plants.

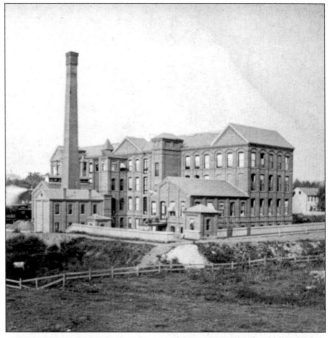

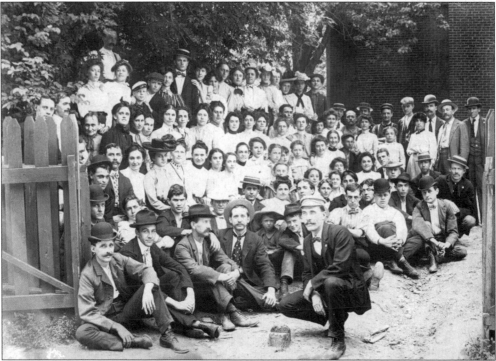

Silk mills in Allentown made broad silks and ribbons. In general, most of the employees were women and girls, with men working as loom fixers and "twisters-in." Employees of the Weilbacher Silk Mill at Front and Gordon Streets are shown here on July 11, 1902. The mill was built in 1897, took up one half of a block, and employed 400. The employees specialized in weaving silk ribbon.

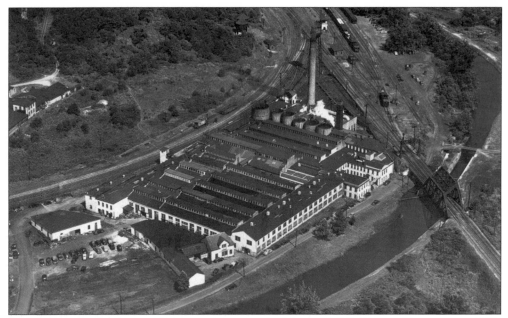

The Allentown Converting Company began as the National Silk Dyeing Company in 1909. Seen in this aerial view is the Lehigh Canal at today's Canal Park. The Allentown Terminal Railroad crosses over lock 40, known as the "dye house lock," as it rejoins the Central Railroad of New Jersey tracks just outside the big Central Railroad yard. This plant was still dyeing and finishing textiles until the late 1970s. The former dye house is now occupied by HAB Industries, a large textile-finishing company.

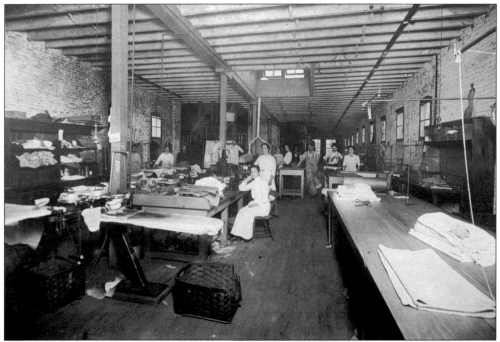

This unidentified shop was one of several Allentown sewing factories that made products as diverse as underwear, petticoats, waists, hosiery, shirts, dresses, overalls, and aprons.

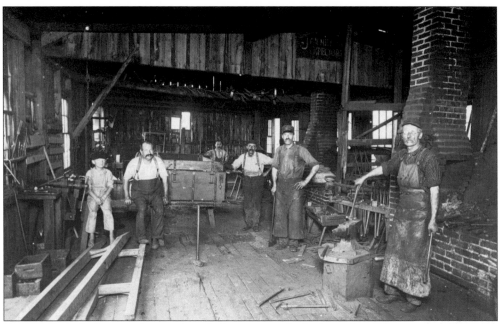

The blacksmith shop in this unidentified wagon works had two hearths, suggesting it was a fairly large establishment. In the 19th and early 20th centuries, Allentown had a number of carriage and wagon makers, but by 1922, they were no longer in existence.

The same wagon works as above is seen here. The man in the doorway is the same man shown sitting on the wagon under construction in the top photograph. In 1913, the major wagon works in Allentown were the Allentown Platform Company at Fifth and Lawrence Streets, founded in 1887; William Wolf's establishment on North Seventh Street, founded in 1835 and specializing in delivery wagons; Christ, Peters, and Company at Hall and Maple Streets, founded in 1881 to produce carriages, light wagons, and auto bodies for delivery trucks; and Enterprise Carriage and Wagon Works at 1025 Oak Street.

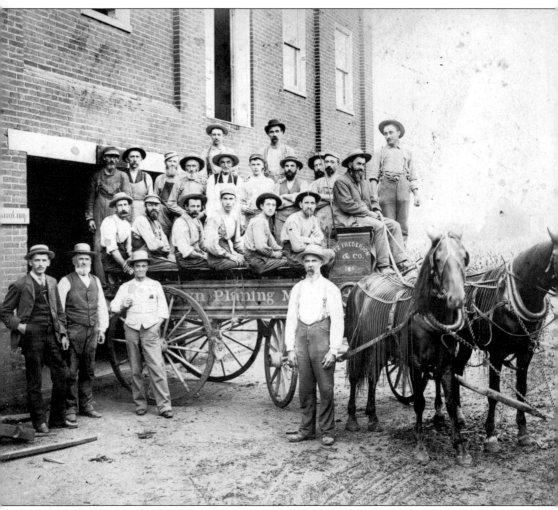

Butz, Frederick, and Company (the Allentown Planing Mill) made window frames, sashes, blinds, doors, shutters, moldings, brackets, scroll, shaping, and all kinds of turned work. It was described in 1886 as the oldest, largest, and best-equipped planing mill in the city. Craftsmen at their shops on Tenth Street, between Hamilton and Walnut Streets, made trim for residential builders. The trim could be found in numerous homes and churches in Allentown and the surrounding area.

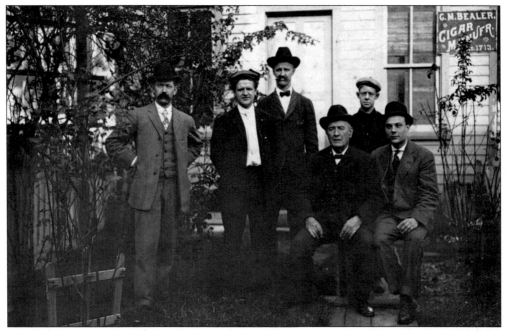

Charles Bealer, standing in front of the door of his home and business at 413 North Sixth Street, was one of many cigar manufacturers in Allentown. In 1914, there were several large plants for the manufacture of cigars, the largest of which employed 200, and about 40 small manufactories such as that of Bealer. One very large plant that served the cigar-making enterprises was the cigar box factory of A.H. Balliet, which made cigar boxes and employed more than 250 people.

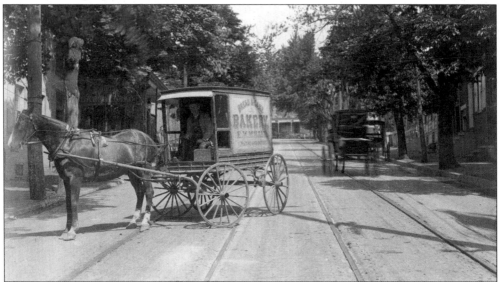

The horse-drawn delivery wagon of Edwin M. Miller's bakery is seen here on Lehigh Street. Edwin Miller, originally from Emmaus, had worked as a baker with his father and uncle for years before moving to Allentown. His bakery, at 730 Gordon Street, also had a grocery store in the front. The Lieberman Eagle Brewery and the home of its owner, Joseph Lieberman, can be seen at the top of the hill. The Lehigh Valley Fitness Center now occupies the site.

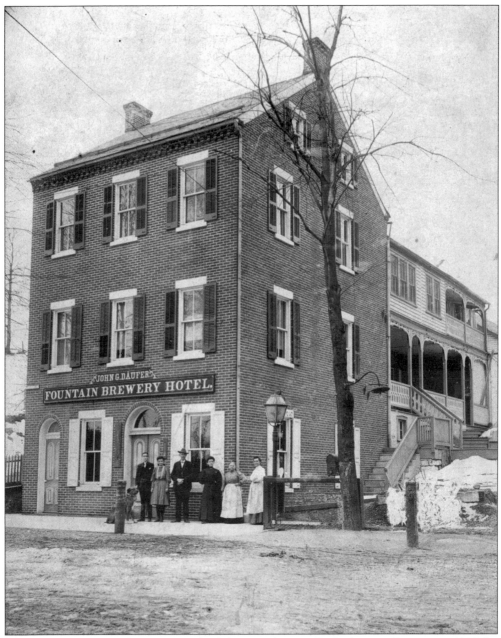

The origins of the Dæufer Brewery, which became the Dæufer-Lieberman Brewery in 1915, lie in the old Koenig brewery. Founded in 1869, on North Eighth Street by Henry Koenig and his brothers-in-law, George and Francis Däufer, Koenig's beer vault was at Jefferson and Lawrence Streets in a "subterranean Arctic city of big vats." In 1876, the brewery, named the Fountain Brewery, was moved to the Lawrence Street site. This brick hotel was built nearby. After the name Dæufer was adopted in 1890, the brewery and bottling works were enlarged. The last beer was brewed here in 1948.

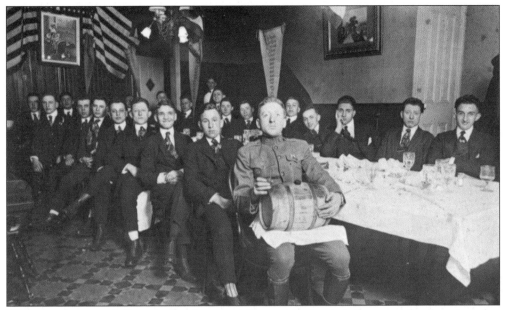

With superb water underground and a strong German heritage, it is no wonder that a number of German-style breweries were developed in Allentown. One of Allentown's best-known breweries was the Horlacher Brewing Company at 311 Gordon Street. A company gathering for the brewing company is shown here. The oil painting of Betsy Ross stitching the flag (on the back wall) was used in Horlacher's advertisements.

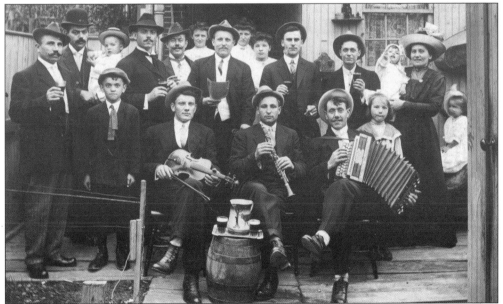

Horlacher Brewery employees and family members are shown enjoying the company brew. Fred Horlacher took over the business, then located at the northeast corner of Hamilton and Fourth Streets, in 1882. He brewed and bottled ale, porter, lager beer, sarsaparilla, and mineral waters. The brewery had been founded by James Wise in 1866 to produce ale and porter. Horlacher's son (also Frederick) kept the business at the same location until 1905. The company lasted until 1978.

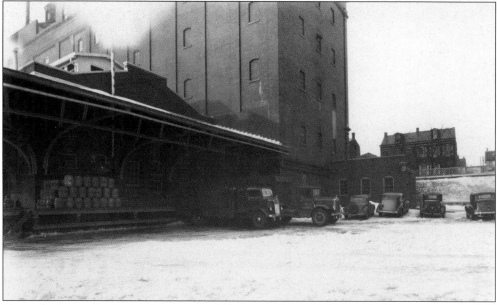

Neuweiler's was the largest brewery in Allentown. Lewis F. Neuweiler became a partner of Benedict Nuding, who had founded the Germania Brewery on South Seventh Street in 1878. After Neuweiler bought the entire business, he moved the brewery to a larger site at Front and Gordon Streets. The imposing buildings that still line Front Street, seen from the rear in this picture, were completed in 1913.

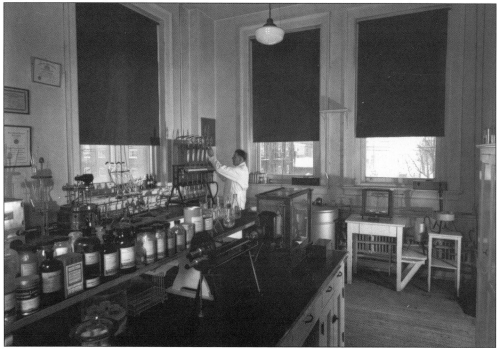

It may look like a chemistry lab, but this is the laboratory at Neuweiler's Brewery, where recipes for the company's line of outstanding beers were perfected. Neuweiler's went out of business in 1968.

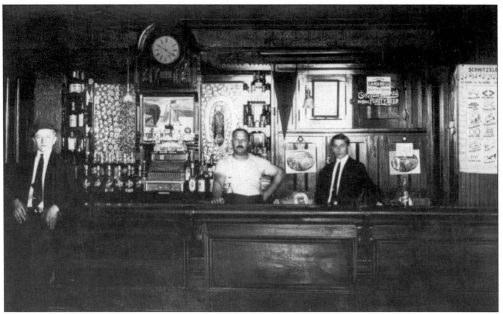

In this unidentified tavern, a sign for Neuweiler's Purity Beer hangs on the back bar. On the right is a feature that would be found in few other parts of the country—a cloth poster showing the words and gestures of the Schnitzelbank song, a popular sing-along in the Pennsylvania German dialect.

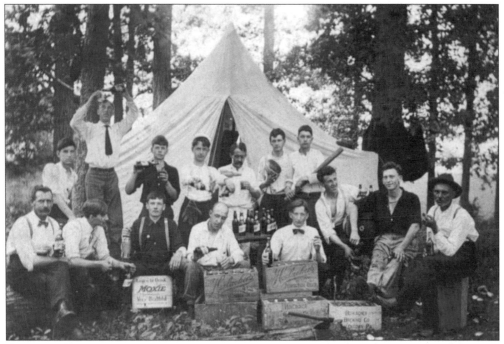

On July 4, 1913, a group of young men took several cases of Horlacher's beer with them when they went for their holiday picnic in a grove. Moxie, which they also had with them that day, was a strong-tasting carbonated drink that was promoted as a healthful beverage with medicinal benefits.

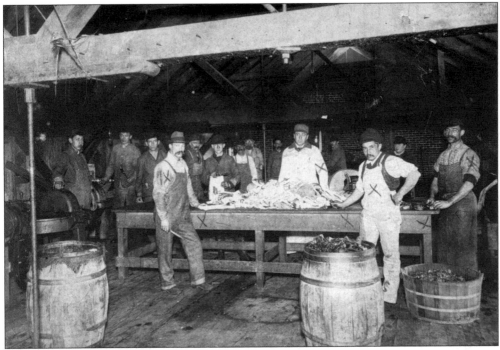

The Arbogast and Bastian slaughterhouse, the largest such business in Allentown, was founded by Wilson Arbogast and M.C. Bastian in 1887. It occupied a prime location along the Lehigh River, just upstream from the Hamilton Street bridge. They were wholesale dealers, selling fresh and smoked meats and sausages. This view of the interior of the butcher shop was taken in 1905.

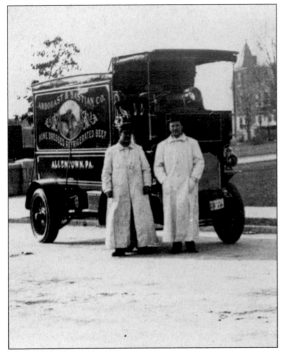

The Arbogast and Bastian Company shows off one of its fleet of delivery trucks for "Home Dressed Refrigerated Beef." The company had contracts with farmers who supplied the animals, and it even owned its own pig farm in Lower Macungie Township. The company expanded a number of times and, after a century of providing high-quality meats, went out of business in 1986.

Peter Jamin owned a butcher shop at 441 Ridge Avenue in the early part of the 20th century.

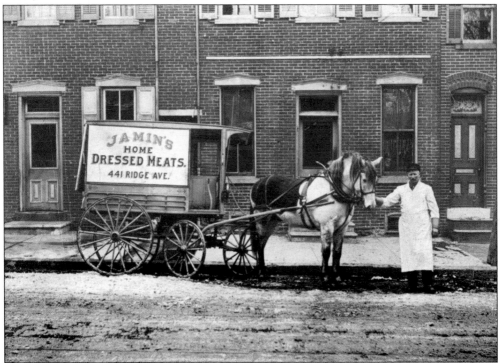

Jamin's delivery wagon is seen here outside his business. He advertised that he was a dealer in choice beef, veal, mutton, lamb, and pork, and a manufacturer of a variety of sausages.

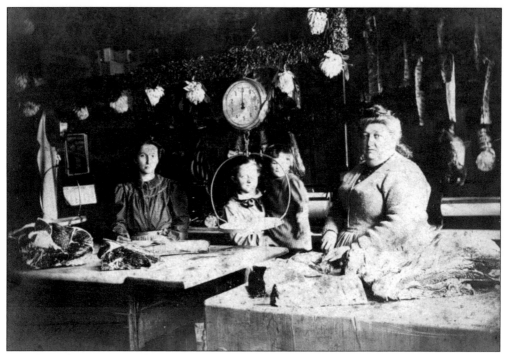

A look inside Jamin's butcher shop shows us not only large pieces of dressed meats ready to be cut to order but also specialty products hanging behind the meat-cutting tables.

Boot and shoe making was a big business in Allentown, with a number of factories competing to shoe the increasing numbers of city dwellers. A good pair of boots had an expected life span of about one year, making this a profitable business. After 1890, there were no tanneries in the area to provide leather. Before then, however, the best-known name in the tanning business was that of the Mosser family.

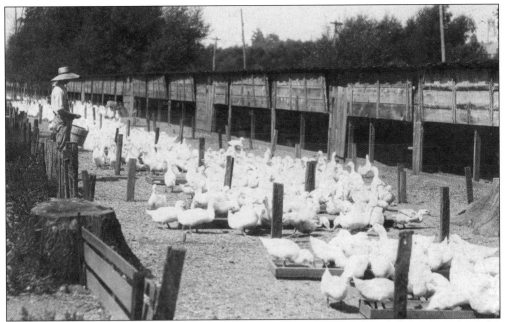

Allentown's best-known farm was the duck farm at Griesemersville, where thousands of ducks were raised for the table. John Griesemer bought land along the Cedar Creek in 1738, and he owned 600 acres at his death in 1789. The present fairgrounds, William Allen High School, and Lehigh Valley Hospital are on land he once owned. The small stone bridge that spans Cedar Creek on the old Reading Road (now Walnut Street), near the former Duck Farm Hotel (now apartments) was built in 1814.

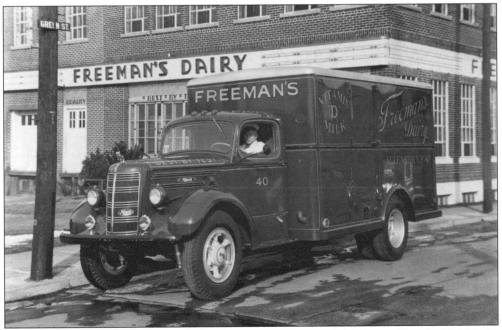

Dairying was a big business in Allentown. Freeman's Dairy used the slogan "Best by Test" in its advertising and was the last city dairy to discontinue home delivery of milk.

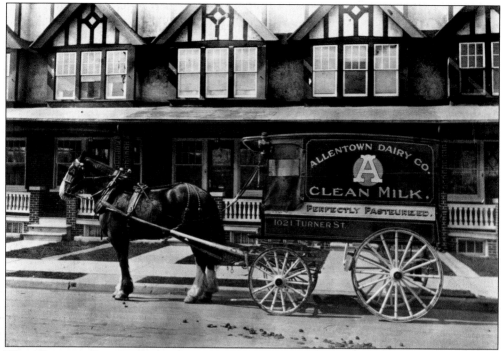

The Allentown Dairy was on Turner Street next to Smith and Peifly, an auto supplies dealer. Although dairies used delivery vans, horse-drawn wagons with rubber tires were preferred by some because they were ideal for stop-and-go deliveries from house to house.

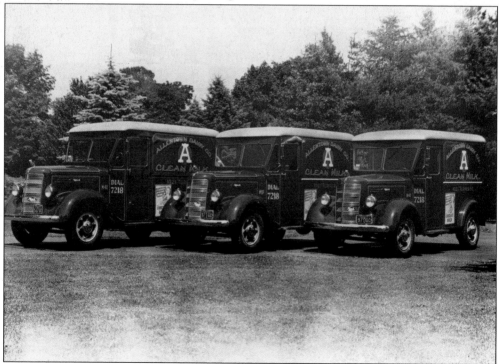

Here we see a lineup of the Allentown Dairy's Mack delivery trucks in 1941.

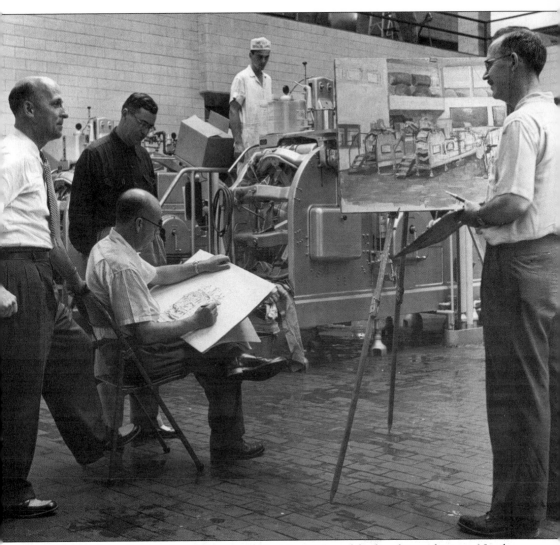

Lehigh Valley dairy farmers formed a cooperative in 1934 and built a large plant on North Seventh Street for processing and distributing milk and milk products. After World War II, the cooperative built an auditorium that was used by community groups for meetings and concerts, as well as a dairy store with a soda fountain. In June 1952, the Lehigh Art Alliance visited the Lehigh Valley Cooperative dairy to draw and paint its operations. This was part of the Art Alliance's "Art in Industry" project, in which members interpreted and recorded work life in Pennsylvania. In this photograph by William R. Zwikl, Quentin H. Smith (director of the project) and Chester S. Dutton (assistant general manager of the dairy) are watching as Garrett S. Conover sketches the bottling line. Conover was the newly elected president of the Art Alliance. Clarence Dreisbach is standing in front of his easel. Zwikl was an artist, using cameras and darkroom as his medium. He worked at different times for the Call-Chronicle newspapers and as head of the photography department at Hess's Department Store. The Lehigh Art Alliance had 142 members then, both professional and amateur artists.

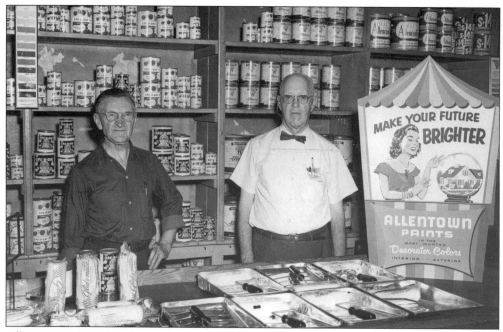

Allentown Paints, founded in 1855 by Jacob Breinig, produced paints under the names Breinig and Allentown Paint in addition to making products that were sold under a variety of names by other paint companies. The company had a "Paint Mobile" equipped with samples of all kinds so homeowners could make their selections at home. The sign in this picture was designed by artist Jim Musselman, who has handled advertising for local businesses for many years.

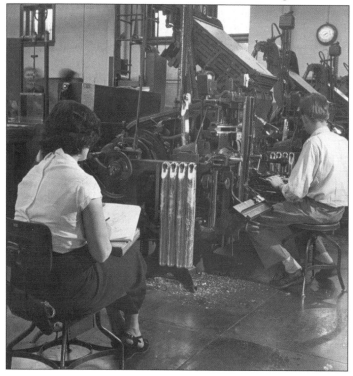

The Call-Chronicle newspapers' linotype machine is being operated by James Luhman while Lucy Essick sketches man and machine. The Lehigh Art Alliance visited the newspaper plant in April 1951 to create "A Portrait of a Free Press," part of its "Art in Industry" project. The Call-Chronicle newspapers were the Morning Call, the Evening Chronicle (which ceased publication in 1980), and the Sunday Call-Chronicle. It was a family-owned corporation until it was purchased by the Times Mirror Company in 1984.

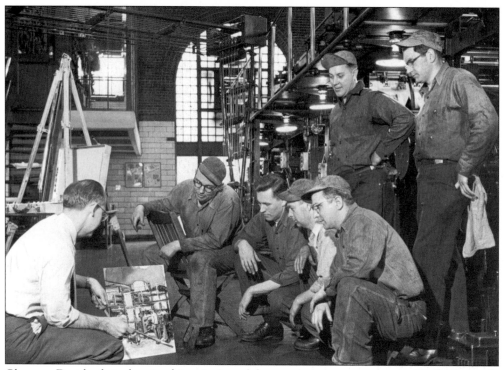

Clarence Dreisbach is showing his painting of the running press to a group of Call-Chronicle press men, some of whom are featured in the finished work.

Gas and electricity were both big businesses in Allentown. Gas was first introduced in 1850, but service was limited to a small area on Hamilton Street between Seventh and Eighth Streets. Larger plants were built at several other sites until the business moved to Third and Union Streets in 1876. The Allentown-Bethlehem Gas Company dates from 1913, when gas companies in Catasauqua, Bethlehem, and Allentown consolidated. The large gas holder that still forms part of the Allentown skyline was built in 1928.

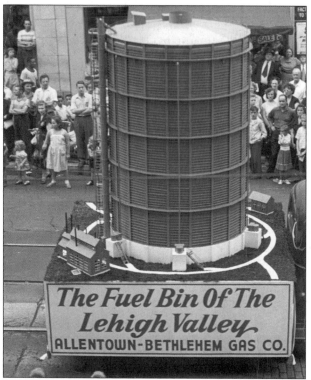

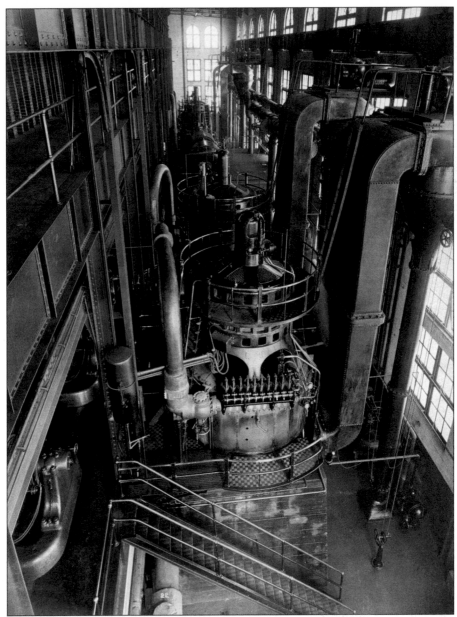

The former Pennsylvania Power and Light (PP&L) powerhouse at Front and Linden Streets is an enormous building, completed in late 1907 by the Lehigh Valley Transit Company. The generating equipment included 500-, 1,000-, and 2,500-horsepower steam turbines. A marshaling yard on the site facilitated the delivery of coal. The plant became part of the PP&L consortium in 1920. Electric lighting was introduced in Allentown in 1882 by William Roney, who purchased a dynamo for his shoe factory in the 800 block of Hamilton Street. A number of nearby businesses bought power from him, and he expanded and incorporated as the Allentown Electric Light & Power Company in 1883. PP&L was formed in 1920, when several smaller electric companies in the coal regions and eastern Pennsylvania, including some trolley companies, consolidated to form one system. In February 2000, the company was renamed PPL Corporation.

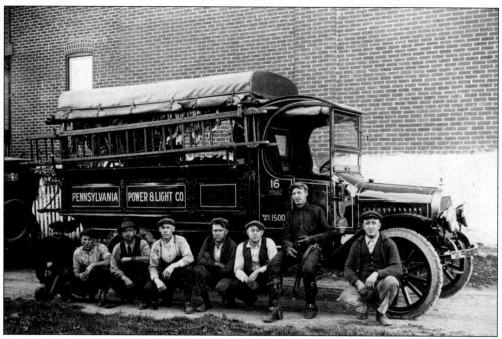

This early line crew posing by their line truck would have worked in one of the cities that PP&L served. Rural electrification did not begin until the 1930s in Lehigh County.

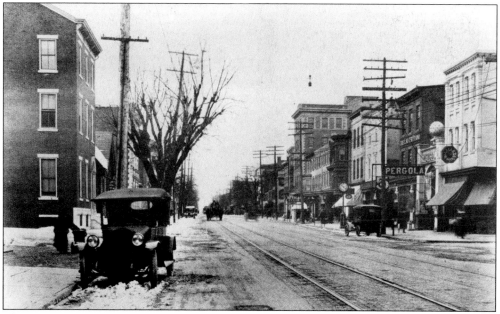

The Martin mansion stands on the left at the corner of Ninth and Hamilton Streets in this postcard view of Hamilton above Ninth Street. The house was torn down in 1960 for a parking lot; later a hotel was built on the site. Formerly the Hilton, it is now the Clarion. In late 1925, the Pergola movie theater closed and, in 1926, was one of the buildings torn down to make way for the PP&L office building. A new Pergola opened on Ninth Street.

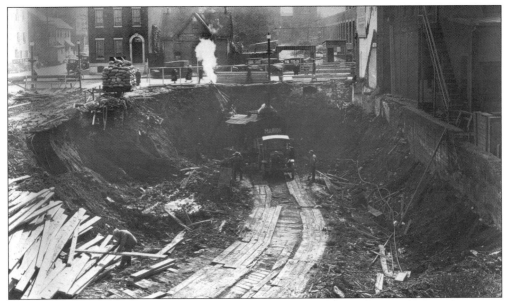

In the mid-1920s, the Pennsylvania Power and Light Company, which had offices in several buildings in Allentown and throughout its service area, decided to build a magnificent corporate headquarters in Allentown. The site chosen was at Ninth and Hamilton Streets. The building not only transformed that corner but became (and remains) the tallest and most outstanding structure in the city. Shown here on October 28, 1926, is excavating work for the foundation.

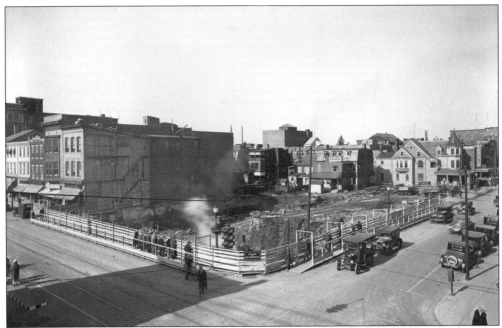

A small crowd of curious onlookers is watching the steam shovel at the PP&L tower site on November 4, 1926. The general contractor was the Hegeman-Harris Company of New York, which determined that the concrete caissons, 48 in number, needed to be sunken 125 feet to find suitable anchorage. The average depth before hitting bedrock was 78 feet.

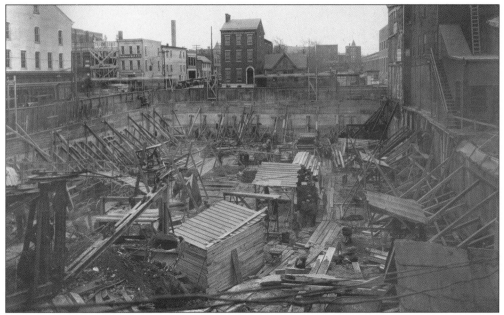

On January 13, 1927, the forms were in place for the foundation of the building. PP&L had wanted to erect its office building on the corner occupied by the Martin house—the fine three-story building in the center of this picture—but Nathan Martin, a reclusive man who lived there with his sister, would not sell. A friend of the Martins, sent by Harry Trexler to ask about buying the property, reported, "The Martins say they don't want to sell because they would not know what to do with the money." A short distance up Hamilton Street from the Martin house is the Dresher lumberyard.

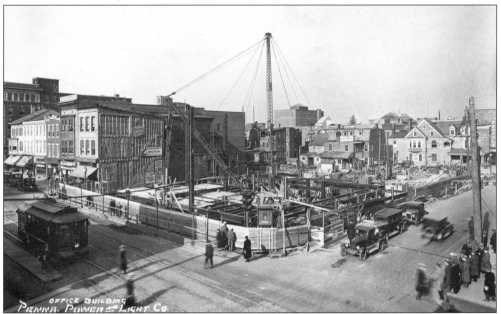

By February 3, 1927, the work had progressed significantly and onlookers could get a good view of the derrick and boom that would raise the structural members over the coming months. Steel erection had begun on January 28.

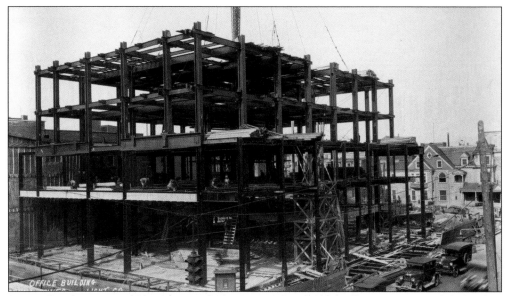

Harry Trexler, one of the principal directors of Lehigh Valley Transit and a leading businessman in Lehigh County, had been the key figure behind the consolidation of smaller utilities into the Pennsylvania Power and Light Company in 1920. He had a grand vision for the company's headquarters, which he wanted in the Lehigh Valley because his home and other business interests were here. By early March 1927, the PP&L tower was taking shape.

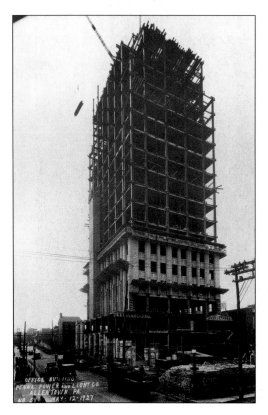

Here we see a view up Ninth Street toward Hamilton on May 12, 1927, as the erection of the structural steel of the 23-story tower nears completion. Brickwork began on April 8. Construction costs were $3.2 million. The building housed the utility's offices on 21 floors and featured a sales and display floor to demonstrate the laborsaving features of modern electrical appliances.

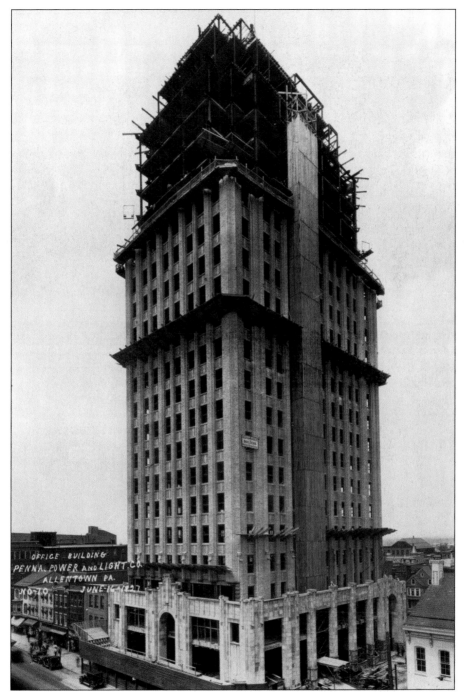

The PP&L tower was designed by the renowned New York architectural firm of Helmle, Corbett, and Harrison. Harvey Corbett and Wallace Harrison came to Allentown to design the 322-foot-high structure, which was a prototype for art deco architecture in New York City. The decorative friezes on the outside of the building were by Alexander Archipenko. The building opened to the public on July 16, 1928. From the beginning, it was illuminated on the outside at night and was visible from most parts of the Lehigh Valley.

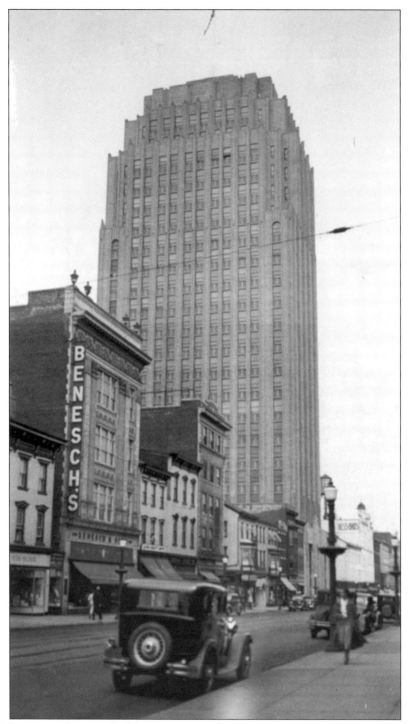

The PP&L tower, photographed by Henry Brucker on May 3, 1936, has been an icon for generations of Allentonians. This view is from the west. A new building is being planned to provide additional office space for the corporation. It will be built on the east side of the Ninth and Hamilton intersection, the site of the former Hess's Department Store.

40

Two
CENTER SQUARE

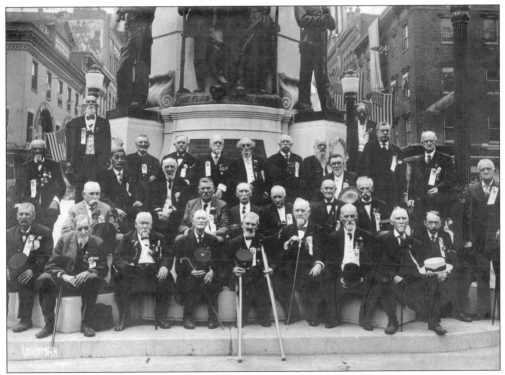

Members of the First Defenders are gathered at the Soldiers and Sailors Monument in Center Square for a reunion in 1911. These men of the Allen Infantry under Capt. Thomas Yeager had responded to Pres. Abraham Lincoln's call for troops and traveled to Washington, D.C., to defend the Union in April 1861.

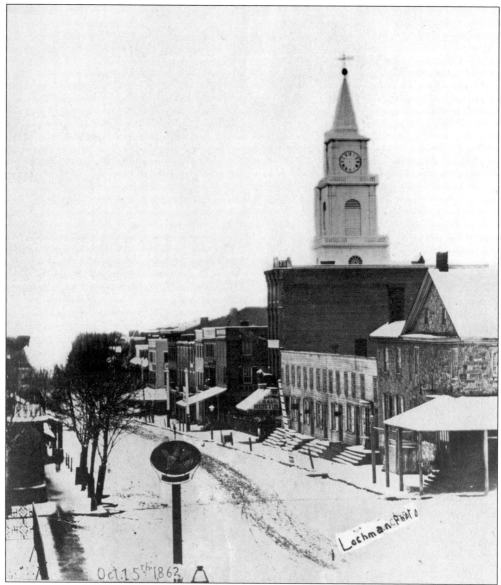

Oct. 15th 1863

Lochman Photo

The earliest known photograph of Allentown was taken on October 15, 1862, by Benjamin Lochman. The view is from the northwest corner of Center Square, then occupied by the Eagle Hotel, and shows Hamilton Street east of the square, with the spire of Zion Reformed Church rising above the buildings.

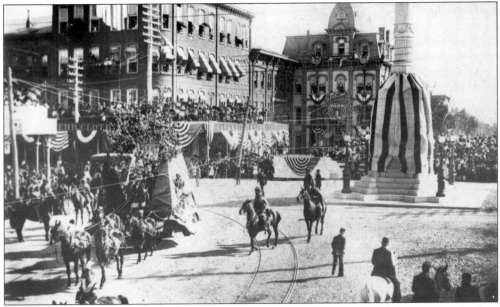

The Soldiers and Sailors Monument, on Center Square, was erected to honor those who had served in the Civil War. The groundbreaking took place in 1898, and the dedication on October 19, 1899. Onlookers at windows, on porch roofs, and standing around the square wait for the unveiling. Gov. William Stone was one of the speakers, and more than 1,000 schoolchildren sang the national anthem as the monument was unveiled. The Shankweiler and Lehr clothing store and the Second National Bank were on the southeast corner.

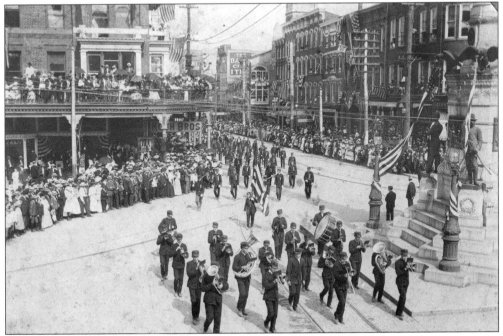

This early-20th-century view of a parade was taken from virtually the same location as the photograph on the opposite page. We can see that Zion Church is about the only old structure still standing.

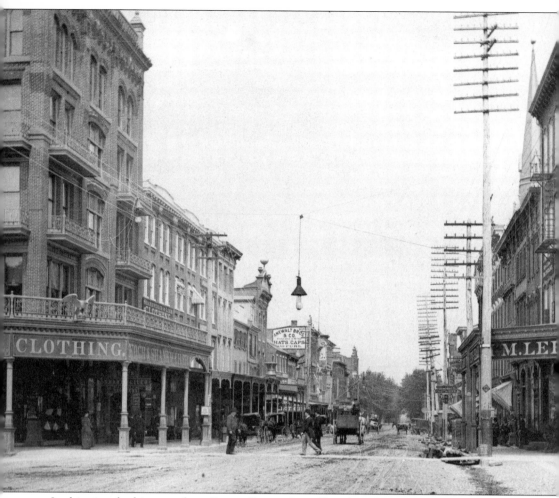

In this view, looking east from Center Square down Hamilton Street in 1891, arc lights are seen hanging above the intersection, while poles are carrying telegraph and telephone lines. On one of the porch posts for the Koch and Shankweiler clothing store is a sign for Bell telephone. This section of Hamilton Street boasted a number of clothing stores. The city had become a shopping mecca for the surrounding towns and villages. Farther down the street is Anewalt Brothers, a hat shop. On the south side the clothing stores include M. Leh and Breinig and Bachman.

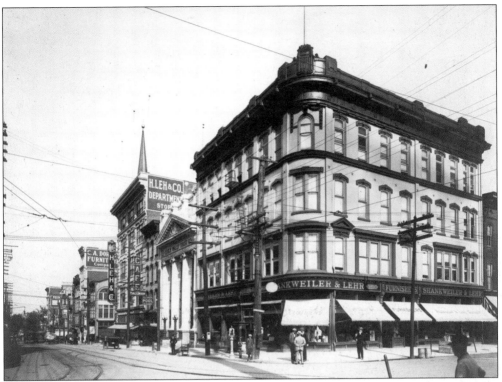

Shankweiler and Lehr, on the southeast corner of the square, was the premier men's clothing store in Allentown. This photograph was taken in 1917.

Shankweiler and Lehr has become Kuhns and Shankweiler, and the streets around the square look much tidier today than they were in the photograph above since wires for telephone and trolley lines have been removed. Radio station WAEB began broadcasting in 1949, and the steps leading to the comfort station under the square can be seen on Seventh Street.

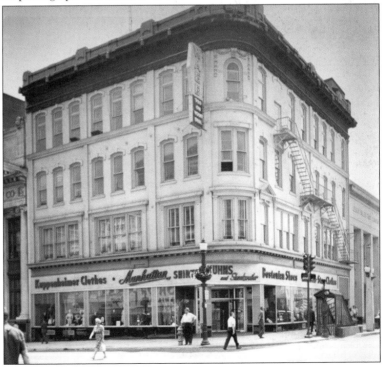

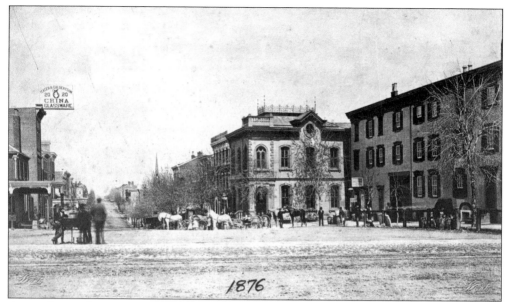

A casual attitude seems to prevail on the square in 1876. Looking north from Center Square in 1876, we see the Eagle House Hotel on the far left, with Yeager's store at 20 North Seventh Street. The Allen House Hotel is on the far right and then the Board of Trade offices and a billiard hall. Allentown National Bank is the imposing structure at the corner where Seventh Street narrows.

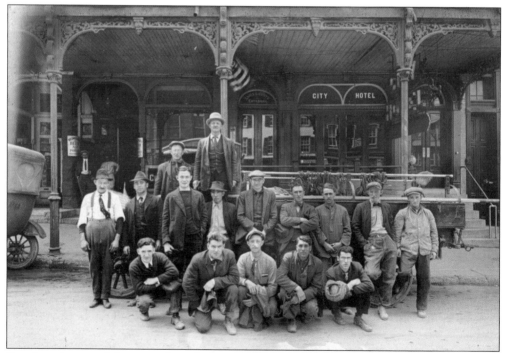

Based on the age of the car and truck that are obscured behind the group of men, this picture was taken after 1917. The City Hotel, formerly the Merchants Hotel, was at 28–30 North Seventh Street. A sign on the post under the porch advertises Neuweiler's beer, ale, and porter.

46

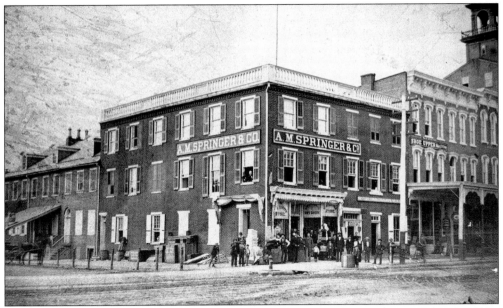

The telephone had recently arrived in town when this photograph was taken in the early 1880s, and wires were beginning to proliferate. Each telephone company strung its own lines right down the main streets. The "Old Corner Store" of A.M. Springer and Company on the southwest corner of Center Square was a popular dry goods and grocery store. It was established in 1874 by Springer and his partners. There had been a dry goods store at the same location for decades before then.

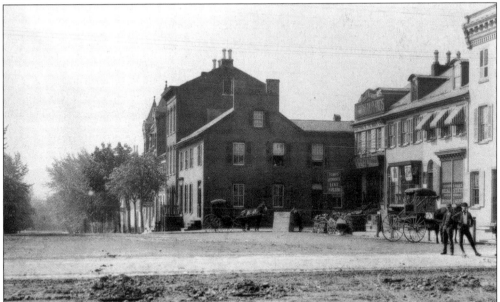

Looking south down Seventh Street from Center Square, we observe that by 1891 the building next to Springer's emporium has undergone major renovation. The offices of Leisenring and Walker, who sold insurance and were also real estate agents and stock brokers, are on the right. In the corner of the square, at 10 South Seventh Street, plumber Joseph Addis had stacked piles of clay pipes.

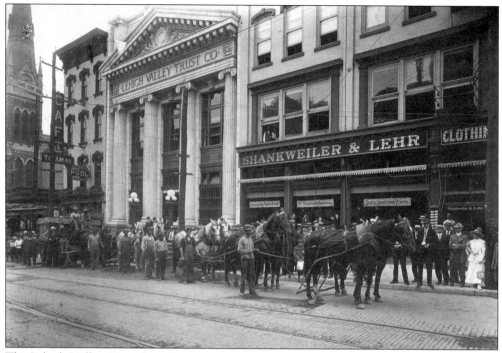

The Lehigh Valley Trust dates from 1886. Its beautiful building near Center Square was built in 1911. It was quite an event when the vault doors were delivered in 1912.

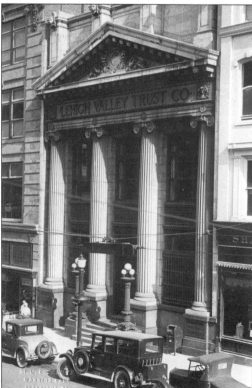

The Lehigh Valley Trust bank building on the south side of the 600 block of Hamilton Street is still one of the city's most handsome buildings. Its front was clad in white marble from Vermont, its four Ionic columns supported a marble cornice and gable, and the lobby was entered through ornamental bronze doors. This photograph was taken in the 1920s.

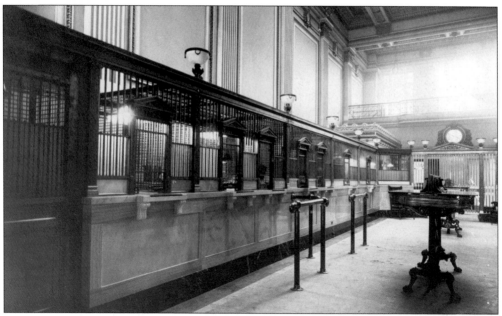

The Lehigh Valley Trust building was impressive, both inside and out, and had a large dome of beaded glass that lit the interior.

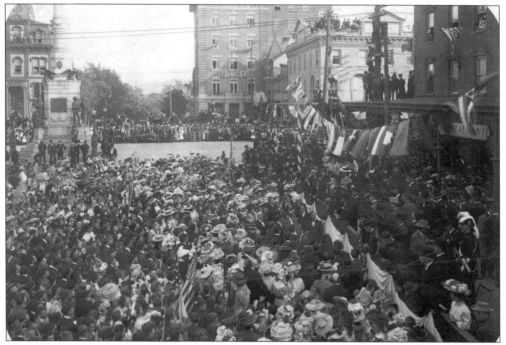

In May 1907, Allen Commandery No. 20, Knights Templar, hosted a large event at Center Square when several prominent men received their Knights Templar degree. Among the honored guests were Spanish-American War heroes Adm. Winfield Scott Schlay and Adm. James McQueen Forsythe; Gov. Edward S. Stuart; and Major General Gobin. Among the thousands who crowded the square to see the parade and dignitaries were 6,000 children, who sang to the accompaniment of the Allentown Band.

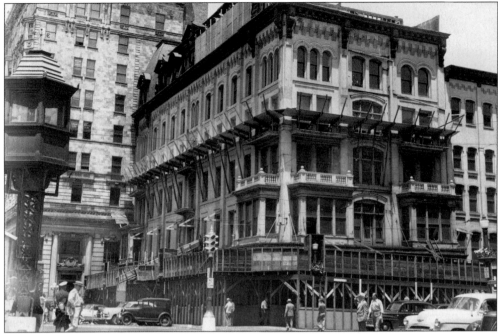

The Hotel Allen, on the northeast corner of Center Square, was a city landmark built on the site of the first hotel in Allentown. Its top floors were removed in 1947 after the building was condemned, and Koch Brothers, who owned the clothing store on the ground floor, modernized the basement and remaining two floors. The rest of the building was removed during the redevelopment period in the 1950s. First National Bank built its offices on the site in 1956–1958.

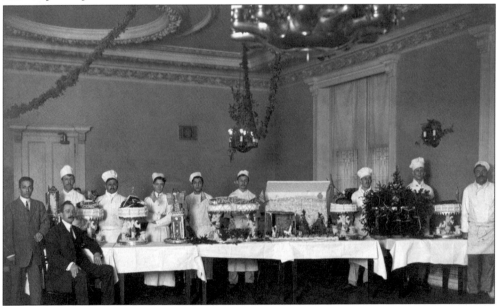

Inside the Hotel Allen on Christmas Day 1912 are, from left to right, steward Harry Freyman; manager Robert Unverzagt; bakers John Ranski, Tom Maurs, and John Kuhns; assistant baker Mueller; waiters Standy Rich and William Wilhelm; second cook Karl Wurthner; and chef Joseph Klein.

50

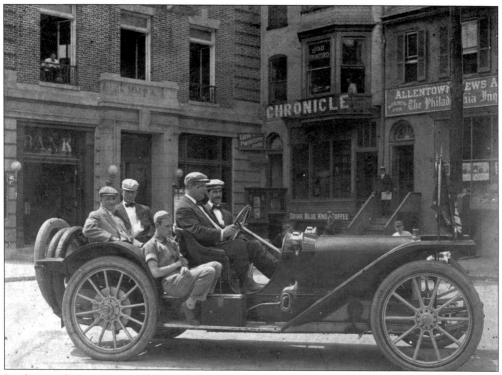

In the southwest corner of Center Square, Roy Iredell sits at the steering wheel of a 1909 American Underslung automobile. In the rear seat is Rodney Iredell. The family owned the *Chronicle and News*, of which Rodney was the manager. American Underslung cars were produced between 1905 and 1914; their innovative design was the brainchild of Harry Stutz.

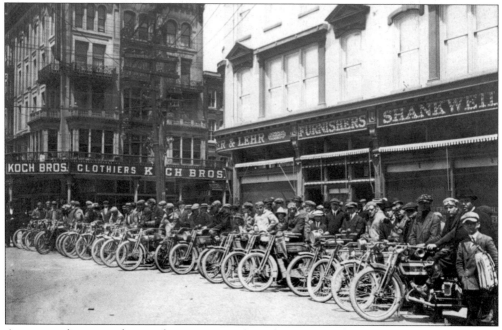

A motorcycle race is about to begin, starting from the eastern side of Center Square, *c.* 1910.

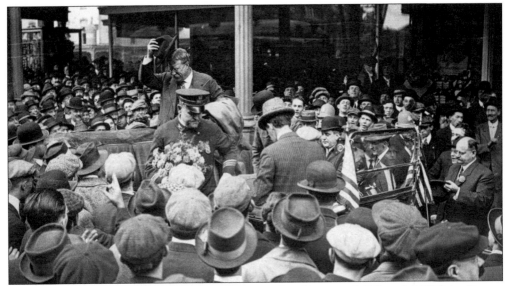

Teddy Roosevelt addressed large crowds (estimated at between 5,000 and 6,000) in Center Square from the balcony of the Hotel Allen on Monday October 26, 1914, while he was on the second of three whirlwind campaign tours of Pennsylvania. He urged voters to elect anti-Penrose candidates, including fellow conservationist Gifford Pinchot for U.S. Senate and Vance McCormick for governor. Pinchot and his wife accompanied Roosevelt on the tour. Roosevelt is shown getting into his car, parked beside Koch Brothers, for the return to the Allentown Terminal Station.

Thousands of Lehigh Countians thronged Center Square to greet servicemen returning from Europe in May 1919. The official parade that welcomed the servicemen was on Victory Day, June 25.

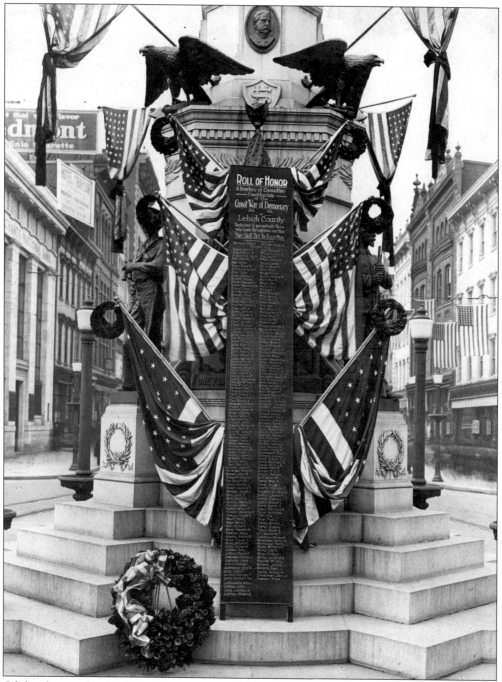

Of the thousands of Lehigh County men and women who served in World War I, more than 200 died. In the second line from the top of the honor roll is the name of nurse Anna Marie McMullen, the only woman from Lehigh County to die in the war. Many of those whose names are on the honor roll died of battle wounds. Others died on the seas or from disease.

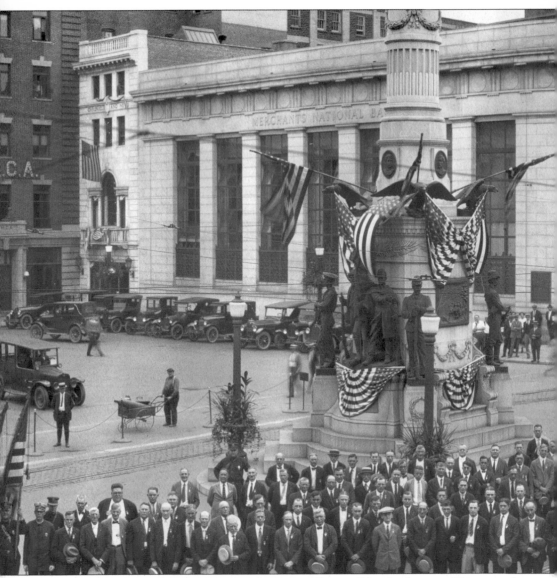

Center Square was used for meetings, celebrations, rallies—all kinds of events. This event from the mid-1920s is unidentified. The men are being photographed from the Hotel Allen. Note

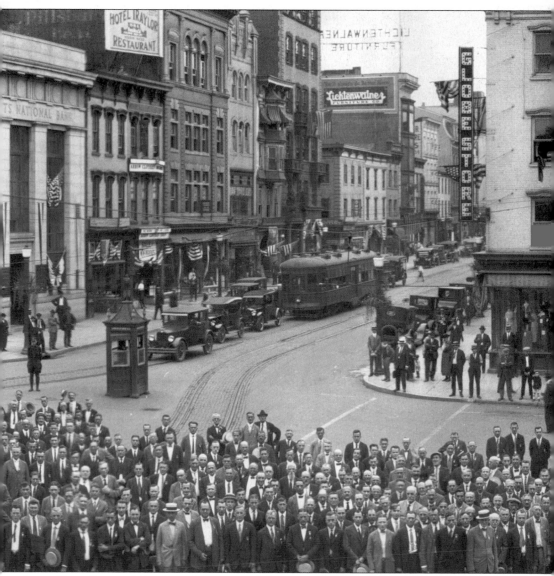

the traffic policeman's kiosk in the center of the intersection and the street sweeper on the far left.

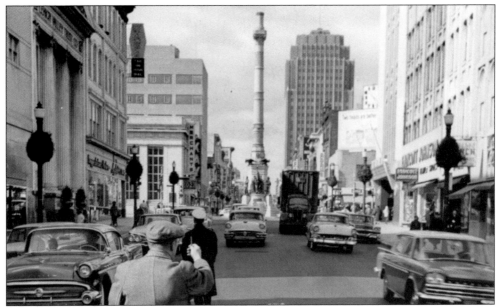

The Goddess of Liberty was taken down from the top of the monument in Center Square in 1958 and not replaced with a new statue until 1964. Until a referendum in 1962, when Lehigh County voted 2-1 to keep the monument at Center Square, city leaders had tried to move the monument to a location where it would not interfere with traffic. This picture was taken during one of the Lehigh Art Alliance's field trips.

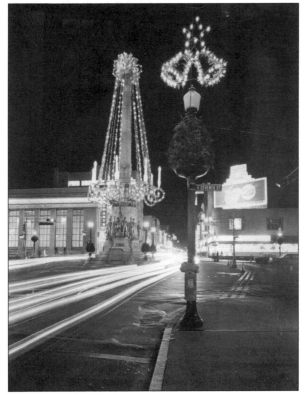

The Christmas lights on the monument and decorations on Hamilton Street are a fond memory for the thousands who made their Christmas purchases on the main shopping street in the Lehigh Valley.

Three
A Place of Businesses

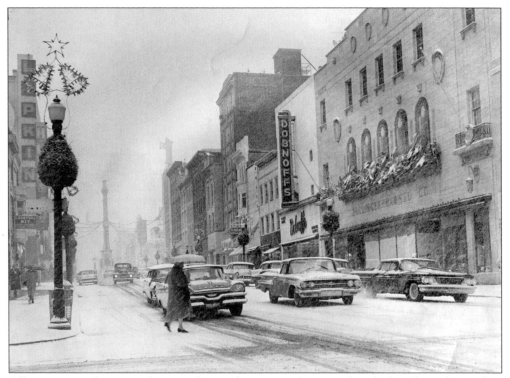

Allentown was the major shopping district for many miles around, with three large department stores on Hamilton Street and numerous other stores. In this pre-Christmas photograph from the 1960s, a shopper crosses Hamilton Street to the Zollinger Harned department store in the 600 block. Lipkins was a furniture store, and Dobnoffs was a women's clothing store.

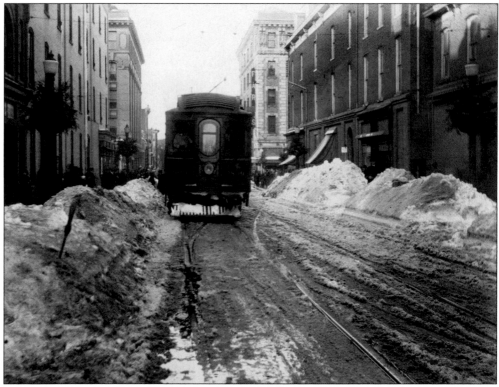

Before shoppers were dependent on private automobiles, trolley cars outfitted with a snow plow would clear streets following snowstorms. If you could get to a trolley car, you could go almost anywhere in the shopping district and to neighboring towns. A crowd is waiting at the trolley station on South Eighth Street to board Liberty Bell trolley No. 809, southbound to Philadelphia, in 1919.

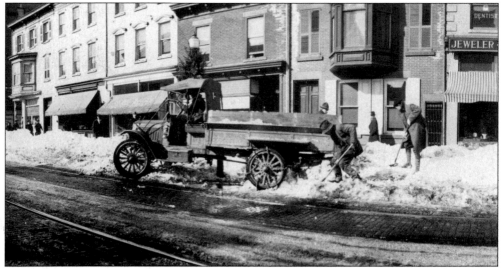

Shoppers are on the sidewalks, and the road has been cleared for trolley traffic. A work crew loads the banks of snow into a dump truck for removal. This scene is at the 900 block of Hamilton Street, outside Freeman jewelers.

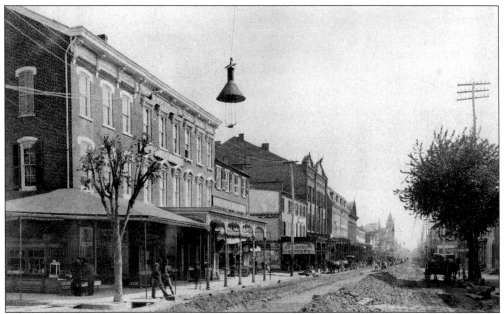

Businesses line the 900 block of Hamilton Street in 1891. The old rails for the horse-drawn trolley were removed that year, and preparations were made for new tracks for the Allentown and Bethlehem Rapid Transit Company's electric trolley. The Grand Central Hotel was in the middle of the block, on the north (left) side.

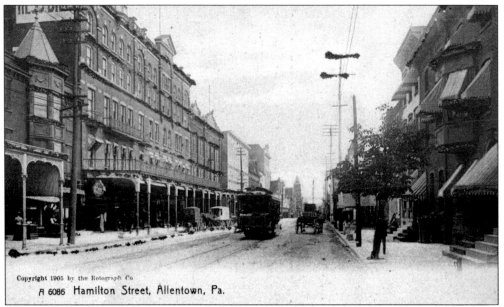

Copyright 1905 by the Rotograph Co
A 6086 Hamilton Street, Allentown, Pa.

Hess Brothers was a young and growing dry goods business that had begun in the Grand Central Hotel at Lumber and Hamilton Streets in 1897. By 1905, the date of this postcard, the store had outgrown its original space and expanded substantially.

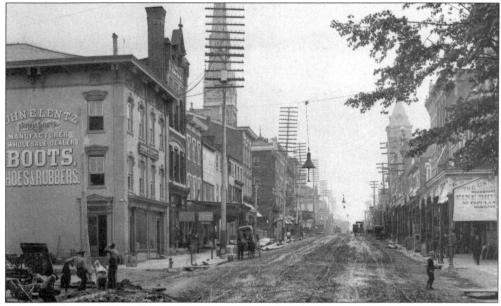

The John E. Lentz establishment, one of several businesses in Allentown that made and sold boots and shoes, was on the south side of Hamilton Street and is shown in this 1891 view of the 600 block. Zion Church is in the center of the block. Across from Lentz's is Kramer's Corner Store, one of the oldest commercial establishments in Allentown. The Pennsylvania Telephone Company offices are in the Ebbecke building, next to Lentz's.

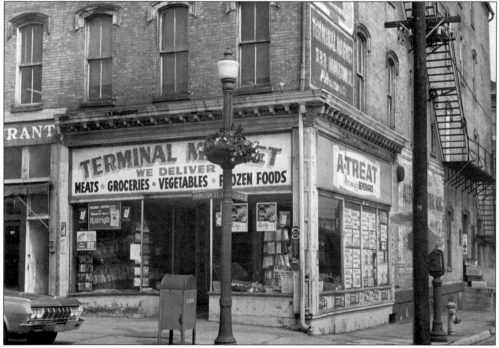

Allentown had neighborhood grocery stores every few blocks. This one, photographed in the late 1950s, is the Terminal Market at the northwest corner of Hamilton and Race Streets, across from the Allentown Terminal Railroad station.

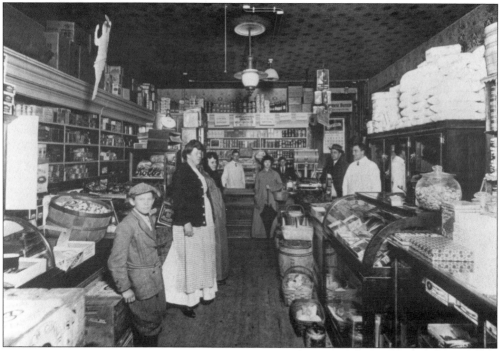

Customers are waiting for service inside the Hoffman grocery store, a typical neighborhood store located at 201 North Tenth Street.

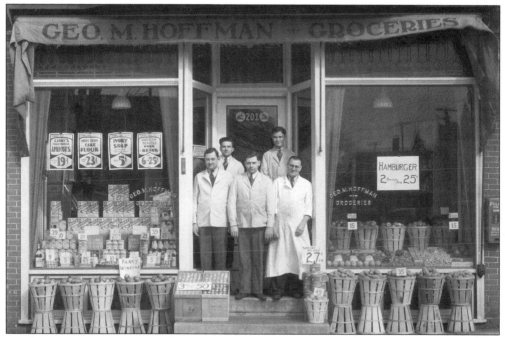

On the left in this photograph from the 1930s is George M. Hoffman, owner of the Hoffman grocery store at 201 North Tenth Street. In the center is his nephew Paul A. Hoffman. The outdoor produce displays feature local fall crops. Lehigh County was famous for its apples and potatoes, which regularly won prizes at the Pennsylvania Farm Show.

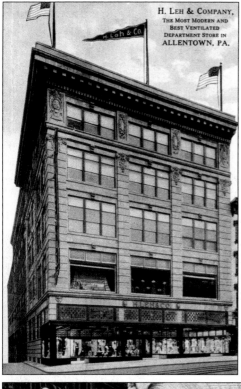

Henry Leh started making boots and shoes in 1850. His was to become the largest such business in the city. The factory and the store, which at one time was the largest clothing store in the Lehigh Valley, were in Lion Hall, 628 Hamilton Street. The modern, five-story store seen in this postcard was built on the same site in 1912. Leh's also had an entrance around the corner on South Seventh Street. The store was converted into the Lehigh County Government Center in the 1990s.

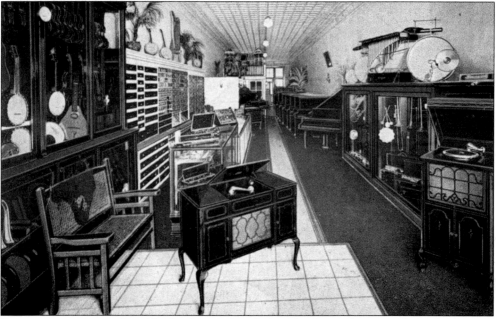

Entertainment was produced by family members before the days of having radio and television in every home. In the 19th century, and well into the 20th century, all middle-class girls learned to play an instrument, usually the piano, and to sing. Boys often learned to play instruments as well. Werley, on North Sixth Street, was one of several music houses that supplied instruments and sheet music for Allentown's large middle-class population.

George A. Wetherhold and Owen W. Metzger opened their first store on December 27, 1907, at 714 Hamilton Street. There was only one shortcoming—it was the "right store on the wrong side of the street." Hamilton Street merchants considered the sunny, north side of the street the favored side. In 1918, the store moved across the street to 719 Hamilton.

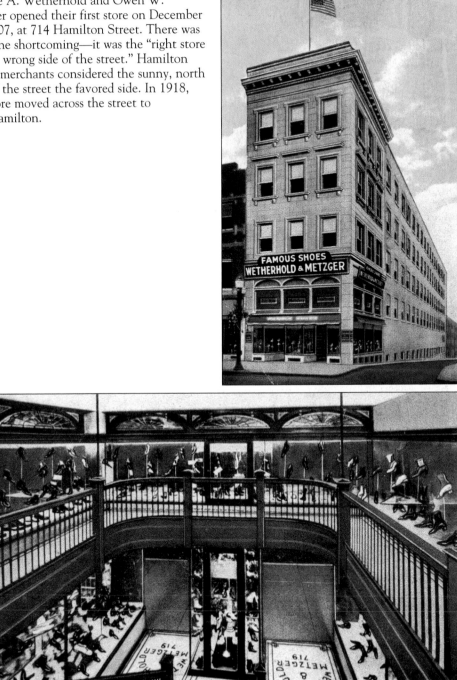

Among Wetherhold and Metzger's claims was that their shoe store would be different from and better than the others—that it would be a service store, a "scientific" shoe store. They specialized in correct fitting and featured the first corrective shoe department in Allentown. Seen here are the balcony windows of the 719 Hamilton Street store. Wetherhold and Metzger expanded to several other locations in Allentown and Reading.

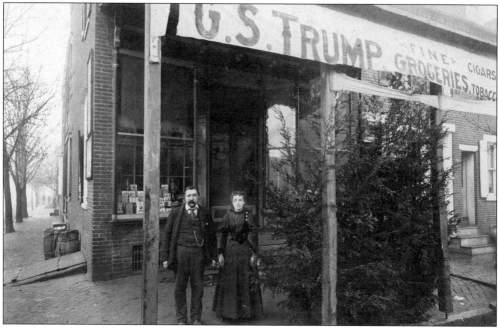

George Trump and his wife, Alice, owned one of the numerous neighborhood grocery stores in Allentown. They are shown standing in front of their store and home at 826 North Seventh Street.

John Werl's butcher shop at 165 Gordon Street specialized in home-smoked meats. In 1940, Werl's Market opened as a neighborhood store at Penn and Cedar Streets, selling groceries, homemade smoked meats, and the finest quality fresh meats.

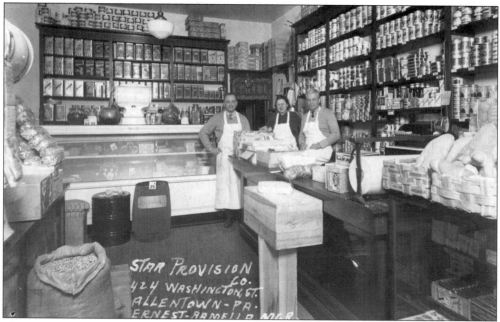

The Star Provision Company, a neighborhood grocery, provided bulk and canned goods and had a cooler for meats and cheeses. The manager was Ernest Ramella-Levis. From 1933 to 1942, the store (shown here) was located at 424 Washington Street in the Tenth Ward. In 1943, it was moved to a building at the corner of Washington and North Penn Street that had formerly been occupied by the Great Atlantic & Pacific Tea Company.

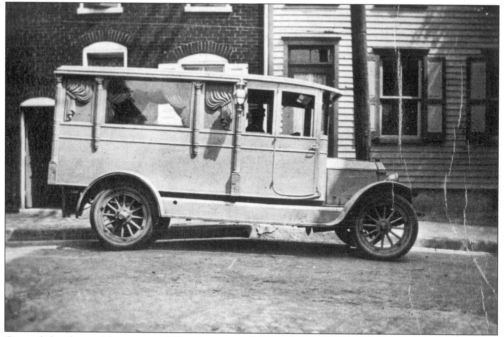

One of the funeral homes in Allentown was Oliver Rabenold's at 116 South Eighth Street, whose hearse is seen here. After Rabenold's daughter Arlene married Ted Trexler, the business became the Trexler Funeral Home.

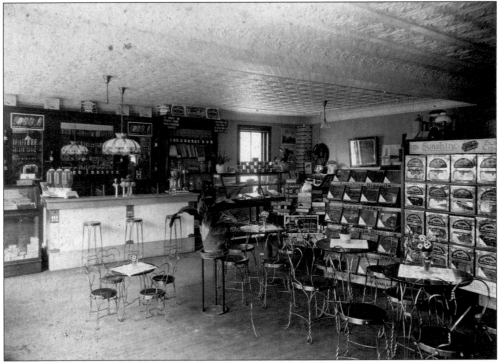

At the southwest corner of Sixth and Hamilton Streets was the Palace Pharmacy. The small table and chairs indicate that children were welcome to enjoy soda fountain treats.

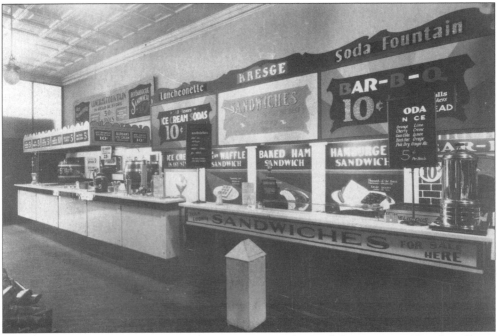

The lunch counter and soda fountain at the S.S. Kresge five-and-dime store on Hamilton Street is ready for customers. There were two Kresge stores on the north side of Hamilton, one in the 700 block and one in the 800 block.

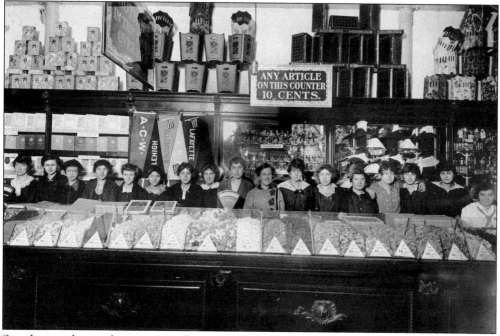

Standing at the candy counter in front of a display of college pennants and under a sign that reads "nothing in this store over 10 cents," these shop girls are ready to face the day.

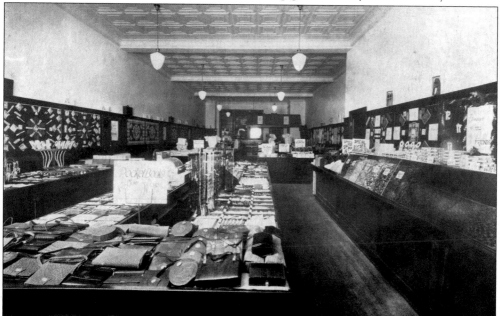

Allentown had a number of five-and-dime stores on its main shopping street. In 1940, there were the Globe store at 710–707 Hamilton; the Central five-and-dime store at 211 Hamilton; Grand F & W Silver Store at 825–829 Hamilton; S.S. Kresge at 715–717 and 809–819 Hamilton; J.G. McCrory & Company at 725–731 Hamilton; and the F.W. Woolworth Company at 815 Hamilton. The narrow aisles behind counters and between the center counters were always tended, often by high school girls earning a small salary.

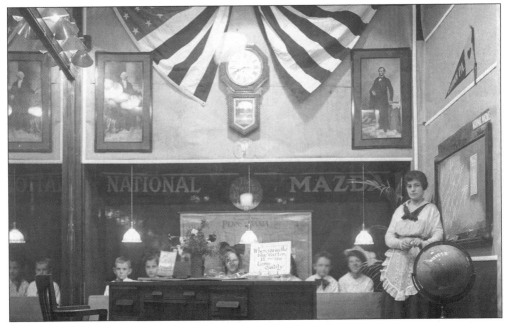

"When you see the blue Carton it means Lamp Quality" reads the sign on the desk in this 1914 window display. The window won first prize—and a Ford car—in a national contest promoting lamps, sponsored by Mazda. The business is not identified but is probably the Lehigh Valley Light & Power Company, which leased space for a showroom from the Allentown Electric Light & Power Company at 542 Hamilton Street.

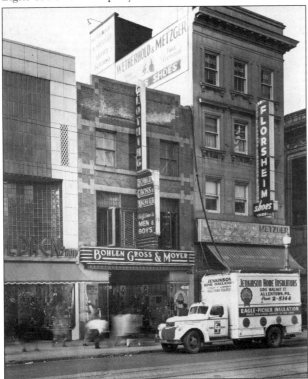

Bohlen Gross and Moyer were men's and boys' "clothiers, furnishers, and hatters" at 721 Hamilton Street, next door to Wetherhold and Metzger's main shoe store. The store was opened by Ray E. Bohlen, William O. Gross, and Frank C. Moyer in 1925. It closed in 1949.

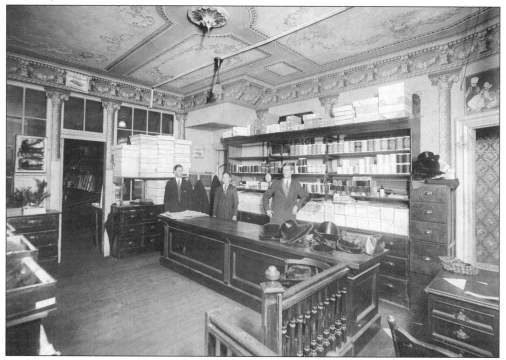

Ritter and Brensinger sold hats and millinery supplies at 42 North Eighth Street. Shown above is the elegant main shop; below is the showroom in the rear of the store.

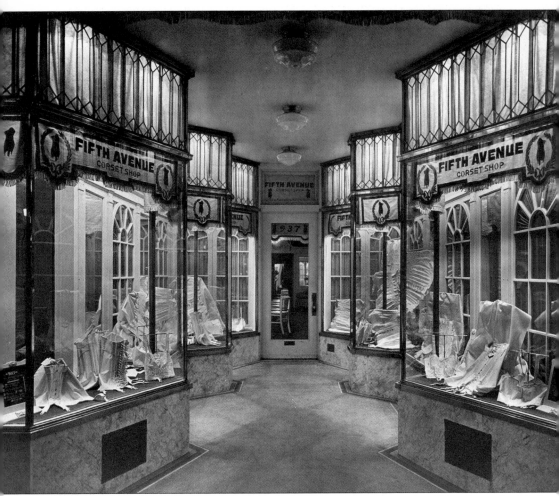

The Fifth Avenue Corset Shop graced 937 Hamilton Street during the 1920s. Later, La Mode Furs took over the store.

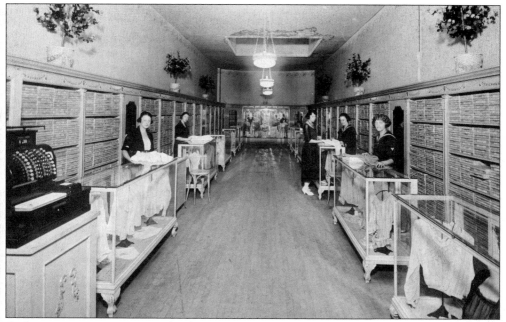

A shop catering to women and girls was the New York Waist Store at 713 Hamilton Street. This photograph was taken on November 11, 1920. A "waist" was a garment that ended at the waist and could be a blouse or an undergarment. For girls who had not developed womanly contours, it was an undergarment to which suspenders could be attached to hold up stockings.

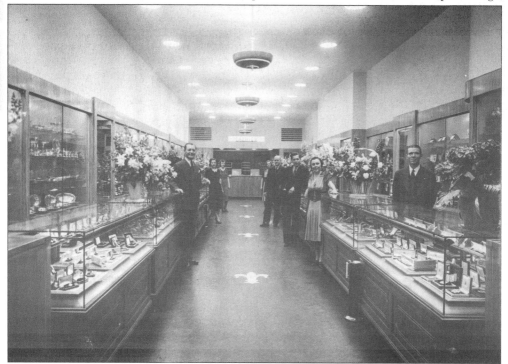

This view is inside Kay Jewelers at 706 Hamilton Street, on April 1, 1939. Note the stands by each counter for cigar and cigarette ash.

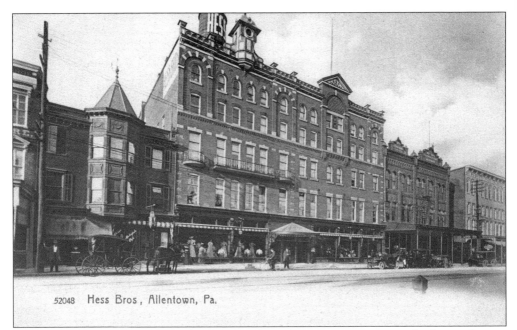

52048 Hess Bros, Allentown, Pa.

The Hess brothers, Max and Charles, from Perth Amboy, New Jersey, opened a dry goods store in the prosperous city of Allentown in 1897. They first rented half of the Grand Central Hotel and gradually enlarged the store. By the early 20th century, it was one of the largest, finest, and most complete stores in Pennsylvania, with 46 departments and 500 employees.

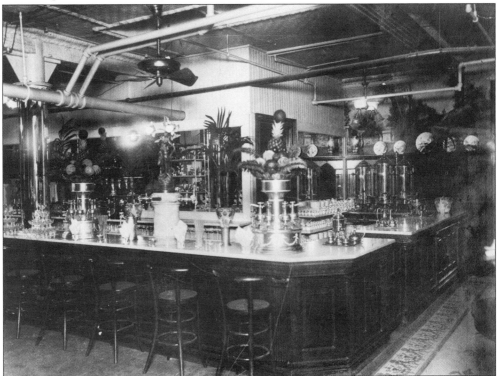

The soda fountain at Hess Brothers was the talk of the town in 1905.

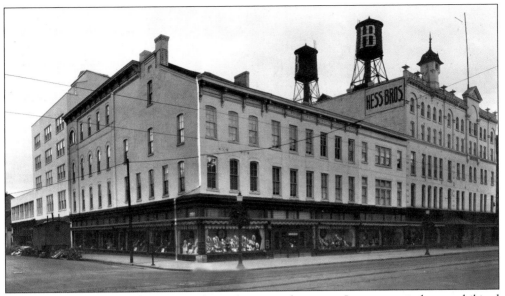

Hess Brothers continued to expand at the same location. Its store windows exhibited fashionable merchandise, and its departments catered to all economic groups. Film stars and other famous people were invited to special events, including the annual flower show, when the store was filled with spectacular arrangements of fresh flowers.

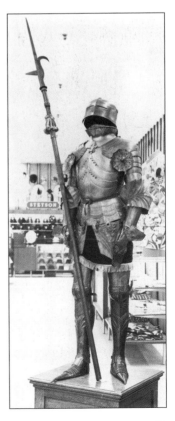

Under Max Hess Jr., Hess's became a store with wonders for everyone. Exotic items of all kinds were on display throughout the store, primarily for curiosity but also for sale. This suit of armor was but one example—and if you wanted to buy it, Max Hess would sell it to you and find something equally unusual to take its place.

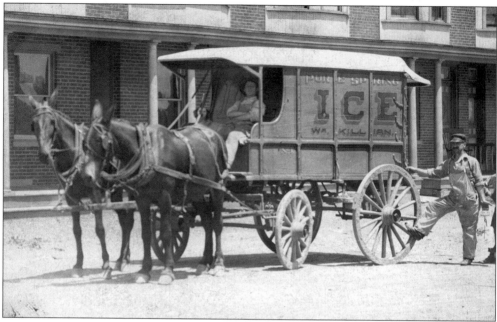

William Killian had an ice pond and storage house at his farm in Schnecksville. Here he is delivering ice door-to-door in Allentown. The delivery man would give lucky children a sliver of ice to suck when he chiseled the large blocks into more usable sizes for his weekly customers.

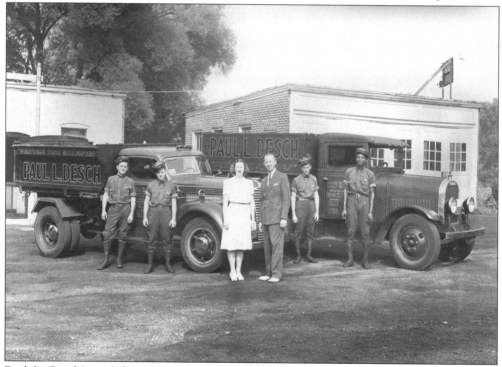

Paul L. Desch's coal-delivery trucks are seen here at the coal yard at 24–30 South Elmo Street. Desch also sold building blocks from his business near the Western Electric plant on Union Boulevard.

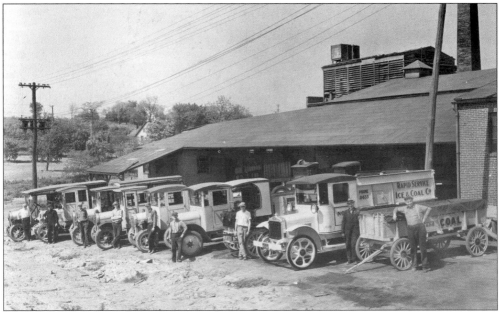

It made sense for a business to combine ice and coal as products. Ice was delivered to homes only in the summer, and most of the coal deliveries took place during the winter. The Rapid Service Ice and Coal Company was at 504 Gordon Street.

Until the 1930s, anthracite coal was used throughout the area for cooking and heating. Marvin O. Ruch was a dealer in Prizer and Lehigh heaters and ranges in the early 20th century.

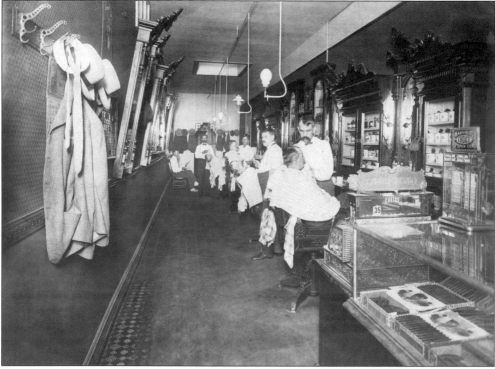

The scene in this unidentified photograph is possibly the barbershop at the Hotel Allen. In this early picture, gas lamps are used for illumination.

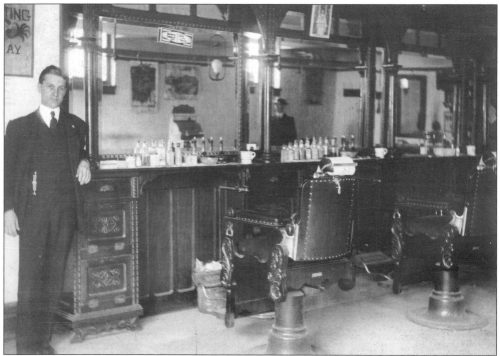

In 1919, Allentown had 70 barbershops. The year and location of this one are unknown.

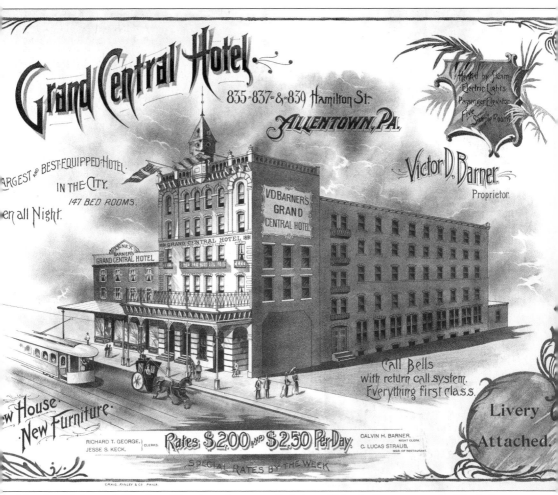

The Grand Central Hotel on Hamilton, between Eighth and Ninth Streets, was the Black Bear Hotel until *c.* 1890. This was where Max and Charles Hess first rented space for their dry goods business in 1897. Until 1891, travelers would be brought to the hotel from one of the railroad terminals on the horse-drawn trolley of the Allentown Street Railway. After 1891, the new electric trolley would bring them. Allentown had hotels and boardinghouses of all kinds during the 19th century and into the first decades of the 20th century. Hotels such as the Allen and the Grand Central accommodated business travelers, of whom there were many in such a thriving city. Boardinghouses were home to many unmarried men and women who had come from other places to work in the silk or iron industries.

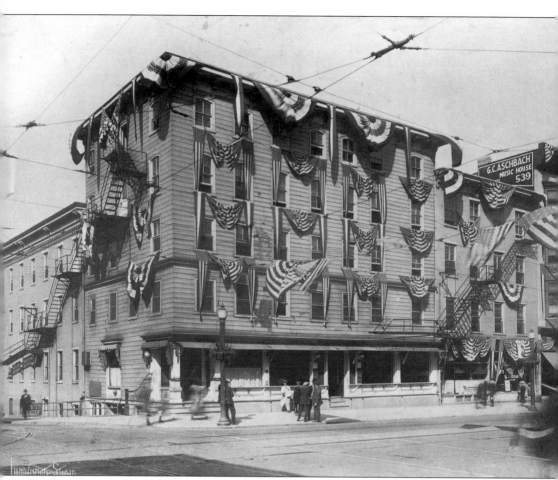

The American Hotel's origins date from 1810, when the population of the little town, then named Northampton, was about 700. In that year, Abraham Gangawere built a two-story tavern on the northeastern corner of Sixth and Hamilton Streets. Later, under the ownership of Charles Seagreaves, the inn was enlarged and renamed the Northampton Inn. The stagecoach line, of which Seagreaves was one of the owners, made its headquarters there. By the time this picture was taken, during World War I, the hotel was 90 by 220 feet with five stories. It was noted for its excellent cuisine and was well patronized by commercial salesmen and the traveling public. This hotel building was demolished in 1924. Its successor on this site, the Americus, was Allentown's largest and grandest hotel in its heyday.

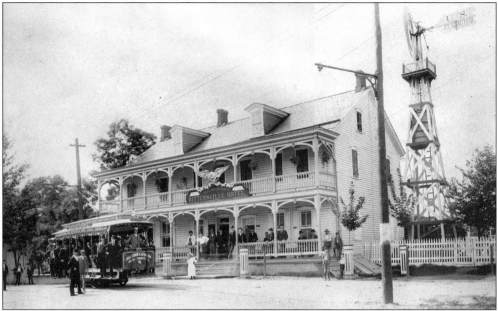

The date is August 2, 1891, and car No. 4 of the Allentown and Bethlehem Rapid Transit Company, carrying company officials, is stopped outside the Rittersville Hotel on its inaugural trip to Bethlehem. The hotel was on the Allentown and Bethlehem Pike, today's Hanover Avenue. In 1893, Central Park was developed by the trolley company near here.

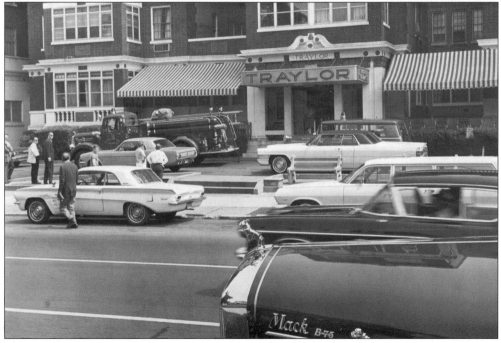

The Hotel Traylor was built by Sam Traylor, of the Traylor Engineering and Manufacturing Company, at Fifteenth and Hamilton Streets. It opened in 1917 as a hotel with luxury apartments and was operated on the temperance plan. Fire equipment is seen here at the hotel in May 1965.

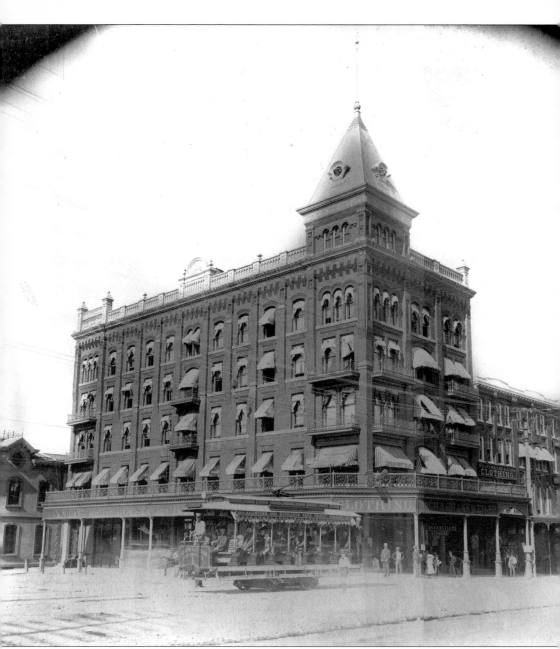

The Hotel Allen, at Seventh and Hamilton Streets, was Allentown's premier hotel for many years. In this photograph marking the first day of operations of the Allentown and Bethlehem Rapid Transit Company, summer car No. 1 is stopped outside the hotel. The electrified street railway started running on July 1, 1891, on Hamilton Street. Service reached Rittersville on July 27 and Broad and New Streets in Bethlehem on August 2. Expansion continued until it was taken over by Albert L. Johnson's Allentown and Lehigh Valley Traction Company in 1894.

Four
GETTING AROUND

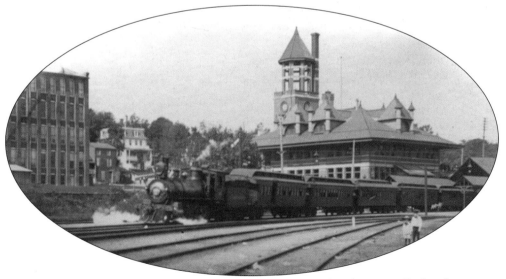

A passenger train is pulling out of the Lehigh Valley Railroad station. Railroads running through the Lehigh Valley were developed early as entrepreneurs sought routes to carry anthracite to the large markets in New York and Philadelphia.

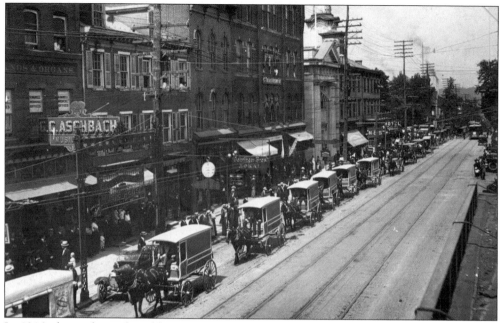

In 1916, the traditional workhorse parade was held for the last time. In this photograph, the Lehigh Baking Company's horse-drawn delivery wagons are parading up Hamilton Street, from Fifth Street toward Sixth Street. In 1915, there were more than 2,000 cars crowding the city streets, but the majority of people still used trolleys, foot, or horses to get around.

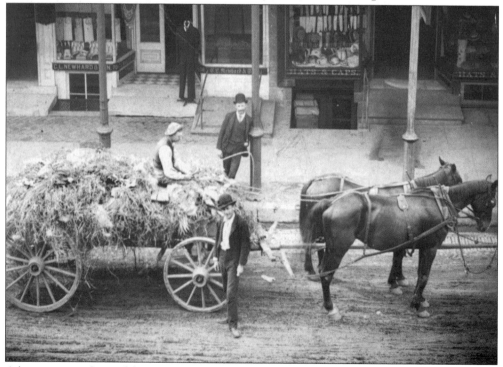

A hay wagon in front of the men's store of C.L. Newhard and Son, at 710–712 Hamilton Street, is a reminder that horses were stabled throughout Allentown.

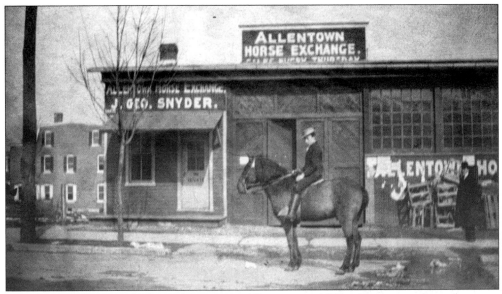

J. George Snyder started a livery business in Allentown c. 1870 and, six years later, began to deal in carriage and livery horses. His stables at Maple and Church Streets, half a block south of busy Hamilton Street, housed 60 or more horses at any time, as well as carriages of all kinds. His was one of several livery stables near the business district.

At the end of 1915, there were still well more than 1,300 horses in the city, and only the main streets had been paved. There was even serious discussion of creating parallel roadways; automobiles would use the paved roadway, and horses would use the dirt one as they had difficulty maintaining their footing on hilly or wet paved roads.

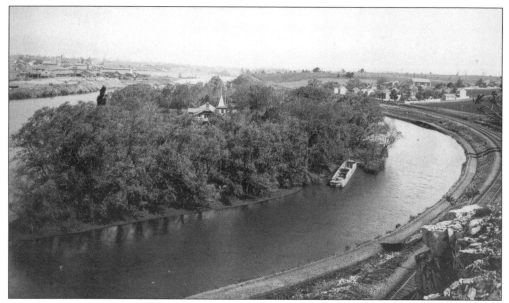

The completion of the Lehigh Navigation in 1829 brought coal, and industrialization, to Allentown. It also brought railroads, as Asa Packer constructed the Lehigh Valley Railroad along the Lehigh River, in direct competition with the canal, to carry anthracite to the same markets. Here we see the canal towpath at Haymakers (now Adams) Island, with the tracks of the Central Railroad of New Jersey running parallel. The Lehigh Valley Railroad was on the opposite side, where the Allentown Rolling Mills can be seen.

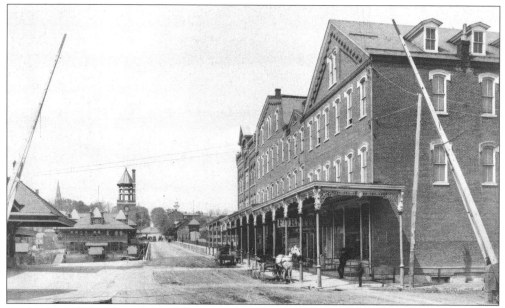

At the foot of Hamilton Street, the railroad grade crossing caused numerous delays in trolley service following the completion of the electrified trolley line to Bethlehem. The Allentown Terminal Railroad station is on the left, and farther up the road is the large Lehigh Valley Railroad station. The furniture factory of Charles A. Dorney and Company is on the right at 333–335 Hamilton Street.

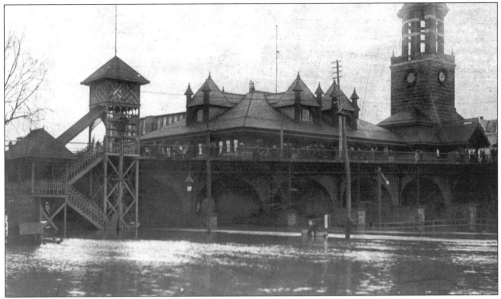

The Lehigh Valley Railroad passenger station was built at the Hamilton Street bridge over the Jordan Creek in 1890. It replaced an earlier station that was a short distance south on Union Street, although the original station remained in use for freight. The new station was large and handsomely appointed, with a restaurant that was widely popular. It was torn down in 1962. It is shown here during the big flood of 1902.

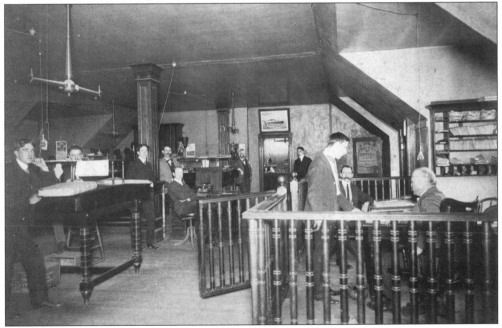

Freight stations were vitally important to railroad operations. This picture was taken inside the freight station of the Allentown Terminal Railroad, which was a short line developed as a joint operation by the Central Railroad of New Jersey and the East Penn Branch of the Reading Railroad. The railroads built a freight and passenger station not far from the Lehigh Valley Railroad station.

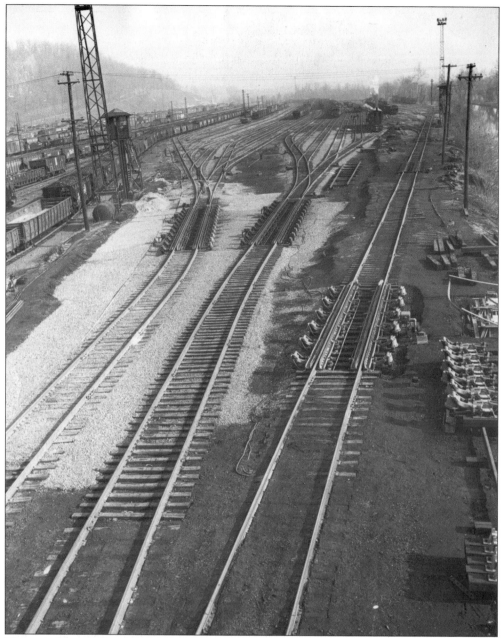

The switching yards of the Central Railroad of New Jersey lay alongside the canal in East Allentown. The contraptions in the center are retarders that control the speed of the free-rolling freight cars as they are being sorted. After the cars roll over the retarders, they are sent to the tracks in the background to make up new trains.

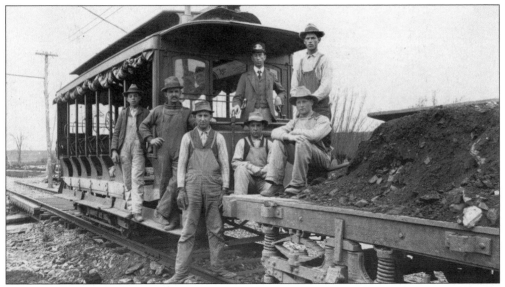

The Allentown and Reading Traction Company was known locally as the "Dorney Park Line." Passengers could get on a trolley at Center Square and go directly to Dorney Park. Construction of the line from the carbarn in Griesemersville westward to Wescosville started in 1898 and was extended to Kutztown and Reading in the following years. Many local students used this line to attend normal school in Kutztown. This photograph of a construction crew was taken in Dorneyville in 1898.

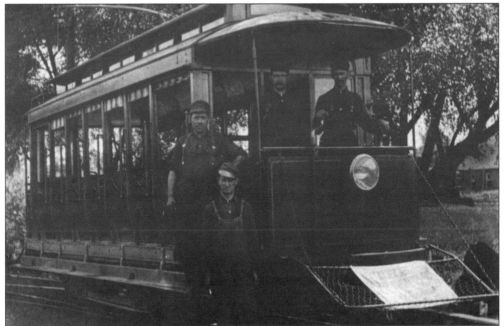

The Allentown and Reading Traction Company's office and freight house on Walnut Street is now in use as a home. The freight car is standing on a siding that led back to a wooden carbarn and an inspection track where Union Terrace is today. The tracks ran on the north side of the road, and a covered platform a short distance west, in front of the Duck Farm Hotel, was the passenger stop.

This trolley is standing at the Allentown carbarn of the Allentown and Reading Traction Company, off Walnut Street, in the summer of 1903. In that year, the company double-tracked the heavily traveled line from Allentown to Dorney Park. The last street railway operations of the Allentown and Reading Traction Company were in 1934, except for the Dorney Park Line, which ran for the last time in March 1936. The company converted to buses on the same routes.

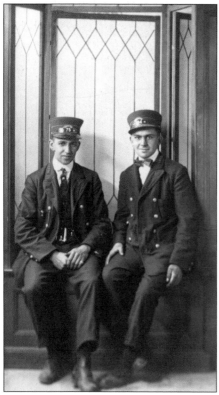

Two young Lehigh Valley Transit conductors, for car No. 75 on the left and car No. 84 on the right, pose for a postcard photographer.

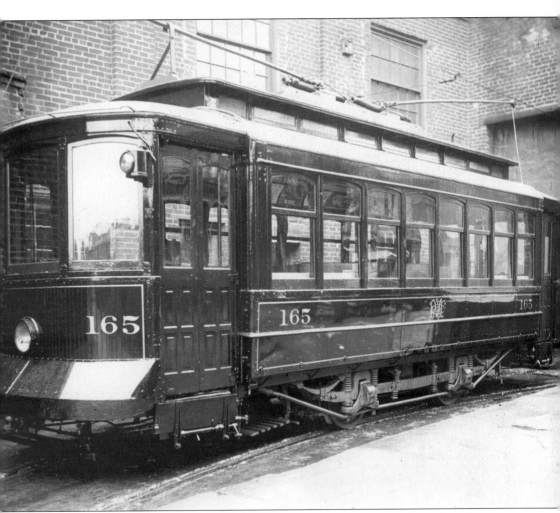

The Lehigh Valley Transit Company evolved out of the Allentown and Lehigh Valley Traction Company, which was organized by Albert L. Johnson in 1893. Johnson tried aggressively to create a far-flung trolley empire spreading out from the Lehigh Valley, acquiring the Allentown and Bethlehem Rapid Transit Company—the area's first electrified trolley system—in 1895. He extended service and acquired other companies. Then, in 1899, he reorganized as the Lehigh Valley Traction Company. Johnson died prematurely in 1902, and in 1905 his holdings were taken over by a group of influential men, including Harry Trexler and Edward M. Young. They merged all of Johnson's interests and changed the name to Lehigh Valley Transit. The monogram on the side of car No. 165, seen above in the Madison Street shops, was adopted in 1907. The Madison Street carbarn had been a stable for the old Allentown Passenger Railway Company. Car No. 165 was purchased in 1907 by Easton Transit Company for use in Phillipsburg, New Jersey. This photograph was taken sometime between 1920 and 1923 when Lehigh Valley Transit was refurbishing some older cars for additional service. The car was scrapped in 1930.

A Lehigh Valley Transit 900 series car is approaching the Hamilton Street Bridge on its way from Bethlehem into Allentown. The trolley is running on the Bethlehem loop in the mid-1920s. The last street railway system in the Lehigh Valley to end operations was the Allentown Division. During 1952 and 1953, buses were introduced on all routes; the last trolley car ran on June 8, 1953.

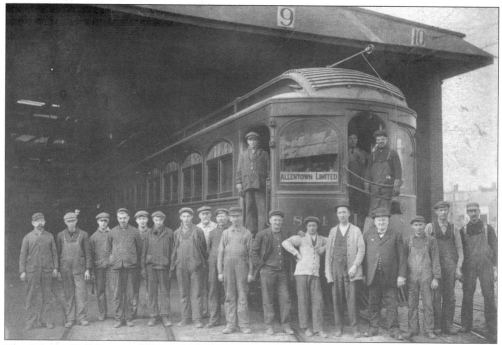

The Liberty Bell Route of the Lehigh Valley Transit Company was a high-speed interurban trolley line between Allentown and suburban Philadelphia that ran from 1903 to 1951. All tracks were removed during the winter of 1951–1952. This is car No. 804 in the Fourteenth Street carbarn in 1912. The carbarn later became a bus garage and is still in use as the Lehigh and Northampton Transit Authority (LANTA) bus garage.

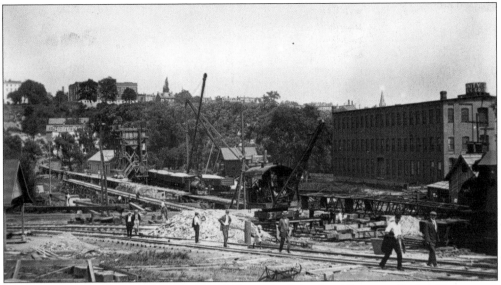

The Eighth Street Bridge, completed in 1913, was built by the Allentown Bridge Company, a subsidiary of the trolley company that was formed for the purpose of constructing a toll bridge across the Little Lehigh Creek valley. Its completion allowed the company to cut the time for the run to Philadelphia on its Liberty Bell Route and opened up land in South Allentown for development. The Yeager furniture factory is the large building on the right in this photograph of preparations for the bridge to be built.

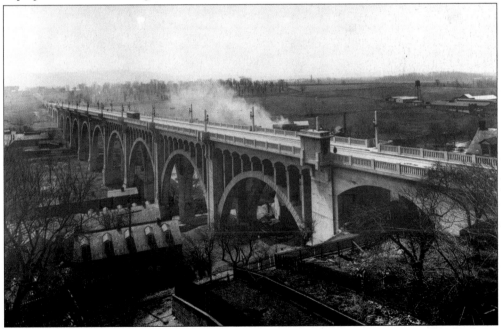

The 1,950-foot-long Eighth Street Bridge, which stands 138 feet above the valley, was the largest concrete bridge in the world owned by a trolley company when it was built. Harry Trexler and E.M. Young, two directors of the Lehigh Valley Transit Company, were also principals in the Lehigh Portland Cement Company. Still a landmark in Allentown, the bridge was operated as a toll bridge until 1957.

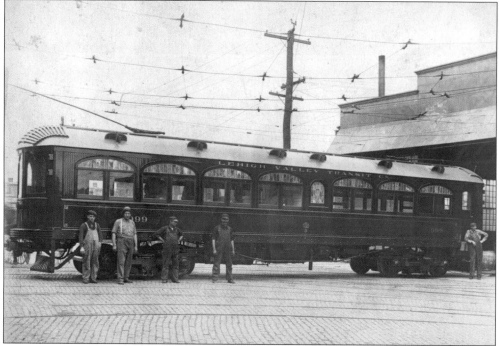

Members of a work crew are standing in front of car No. 999—a private, heavy interurban trolley car—at the carousel at the Fourteenth Street carbarn in August 1914. The car was constructed there and was converted to passenger car No. 812 in 1921. Pres. William Howard Taft rode on this car on one of his three trips to Allentown.

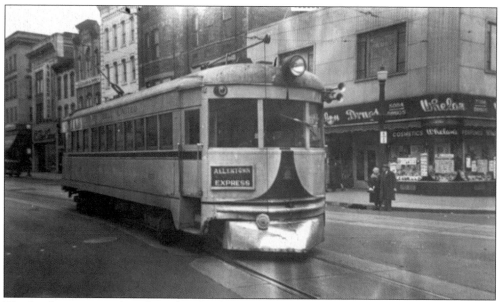

The familiar cream and scarlet colors for the Liberty Bell Limited cars were adopted in 1938, at the beginning of a modernization program that flew in the face of the national trend away from light rail systems. The trolley car is shown going around the monument at Center Square. Whelan Drugs was at the northwest corner of the intersection.

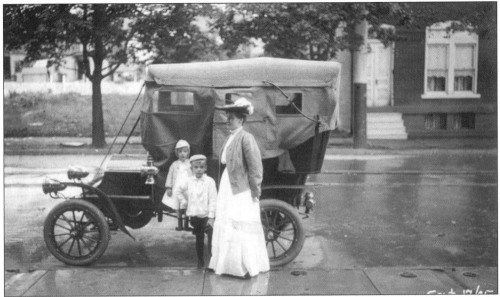

Private automobiles had been encroaching on the trolley lines' business since early in the 20th century. At first, only wealthy families owned cars, for use primarily in the summer. This photograph, dated September 17, 1905, is of Mrs. John Greenall and children standing by their 1904 four-cylinder, air-cooled, cross-engine Franklin. The Greenalls were partners with Charles Mosser in W.F. Mosser and Son, a foundry and machine shop.

The first Allentown Automobile Show was held in 1917, with 80 cars on display. The city was then actively paving main streets to encourage the use of automobiles. An early dealer was Lawfer Ford (on Hamilton Street between Twelfth and Jefferson), which later became Dahl Motors.

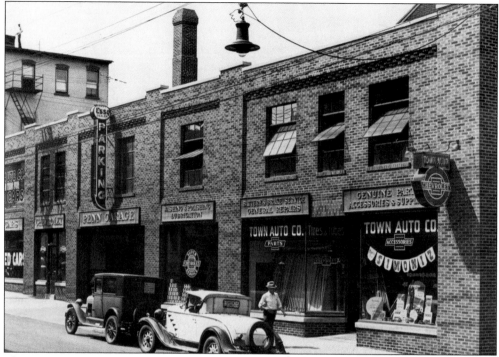

The Town Auto Company at 635 Linden Street, owned by the Schadt brothers, was a full-service dealer, selling new and used cars, parts, and accessories. This photograph of the business was taken in 1937.

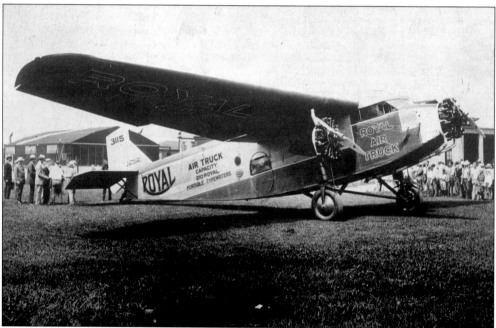

The first air freight in Pennsylvania was received in Allentown on August 22, 1927. The shipment, on a Royal air truck, was of Royal typewriters from Hartford, Connecticut, sent to Frank Haberle, who owned the Royal Typewriter Agency at 113 North Sixth Street.

Five

FUN TIMES

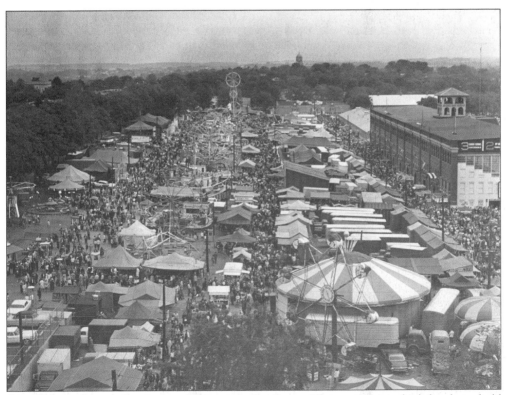

One of the most popular events of the year is the Great Allentown Fair, which has been held in September since the middle of the 19th century. "Big Thursday" of Fair Week, when entrance was free, has traditionally seen the highest attendance of any other day, with an attendance of more than 100,000. This picture dates from the 1960s.

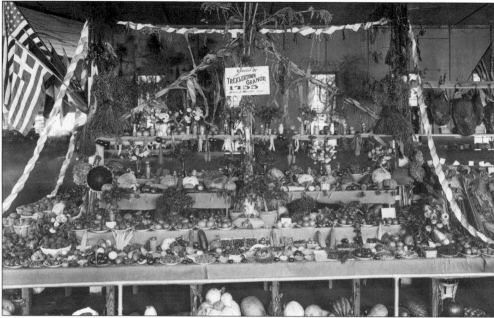

The Great Allentown Fair is a county fair and was once the highlight of the year for area farmers. While today the agricultural exhibits are modest, until relatively recently the contests for best livestock, best products, and best displays were very competitive. This display of the Trexlertown Grange in 1915 shows the bounty produced by area farm families.

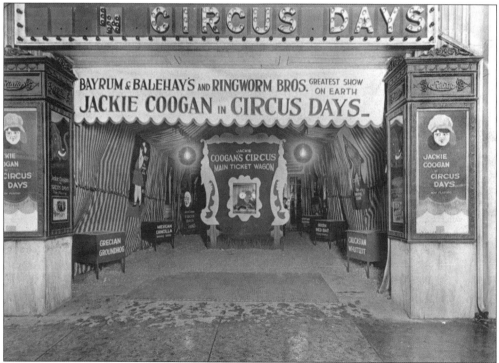

The Rialto Theater opened in 1921 in the 900 block of Hamilton Street. *Circus Days*, one of the early shows performed there, featured child star Jackie Coogan playing Toby Tyler.

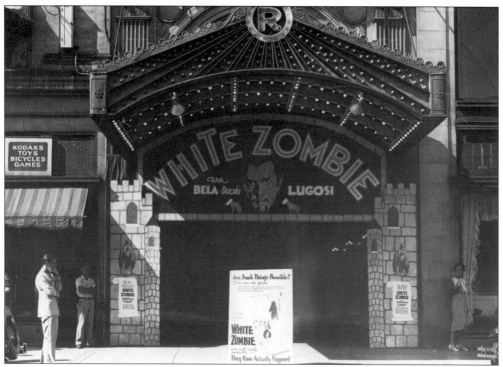

"She was not dead . . . Not alive . . . Just a White Zombie," reads the publicity for *White Zombie*. Bela Lugosi was the evil Haitian hypnotist Murder Legendre in this 1932 movie.

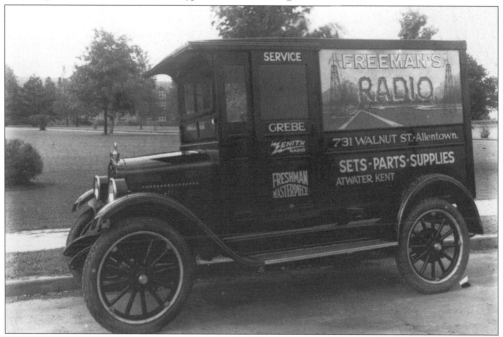

Radio came to Allentown in 1922 and, although radio sets were still expensive, became very popular by the end of the 1920s. Freeman's was one of several stores that began to sell radios and parts.

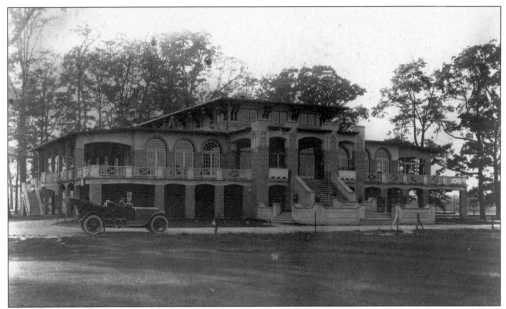

The Allentown Golf Club opened the first golf course in Allentown in the early 1900s on a tract bounded by the Cedar Creek, Walnut Street, Seventeenth Street, and the Ziegenfuss Quarry. The nine-hole golf course and club building of the first Lehigh Country Club opened in Rittersville at Club Avenue and Union Boulevard in 1912. This is the outside of the club building.

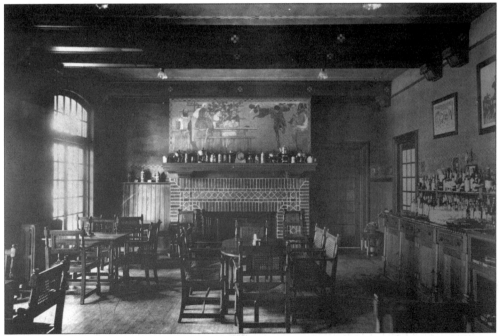

In 1919, Prohibition required that the bar at the old Lehigh Country Club, seen here, dispose of all alcoholic beverages. By the time of repeal, the club had moved to its new, larger location along Cedar Crest Boulevard. The new site, where the club is today, was acquired in 1925 because of the increasing popularity of golf and growing interest in club membership.

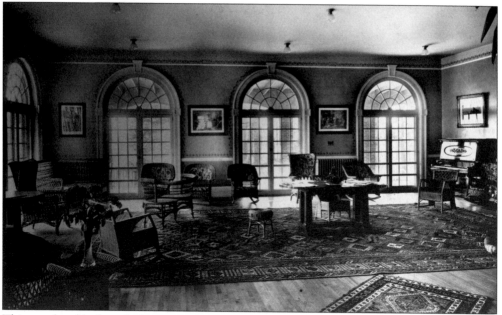

This comfortably furnished room in the original Lehigh Country Club is a far cry from how the former clubhouse looked in later years. After the club moved to its present location, in the late 1920s, the original, unchallenging flat golf course remained open to the public, and the building slowly deteriorated. The Lehigh Shopping Center was built on the tract in 1961.

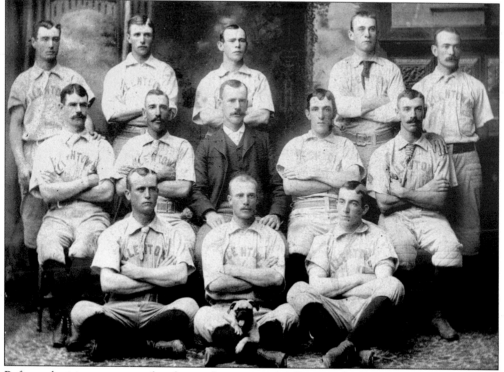

Before television, every ward and many businesses in Allentown had sports teams. Games were played in open lots before ball fields were constructed.

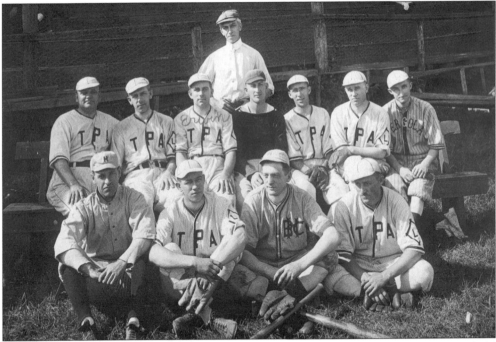

The Pergola team was semiprofessional and highly popular. In the days before every household had radios or television, a mural of a baseball field would be set up outside the second floor of the Evening Chronicle building (in Center Square) during the World Series. Crowds would gather to watch figures being moved around the bases as news came in by teletype.

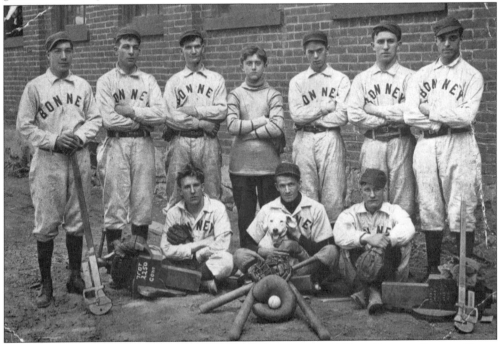

Bonney Vise & Tool Works, which moved to Allentown in 1909 and is now Bonney Forge, produced postcards so members of its baseball team could send them to friends and family.

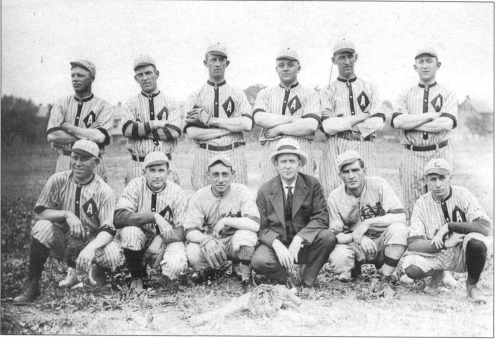

The Lehigh Valley A's represented the north end of Allentown. Robert Hartzell is third from the right in the front row.

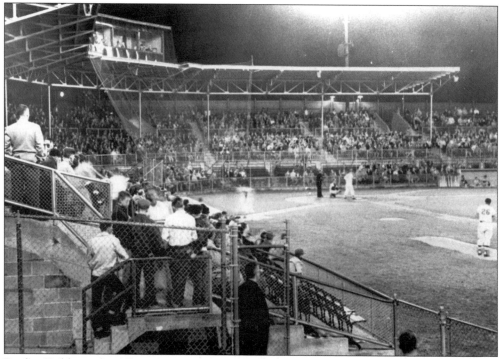

Braden Field was the Allentown area's main field for semiprofessional sports events. It is where the Lehigh Valley Mall is today. Until the downturn in the popularity of minor league baseball in the late 1950s, games here were well attended.

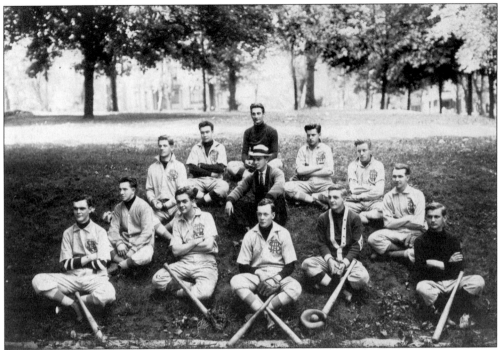

The Allentown Preparatory School, a private boys' school, had football, basketball, and baseball teams for different age groups. This is a senior boys' baseball team.

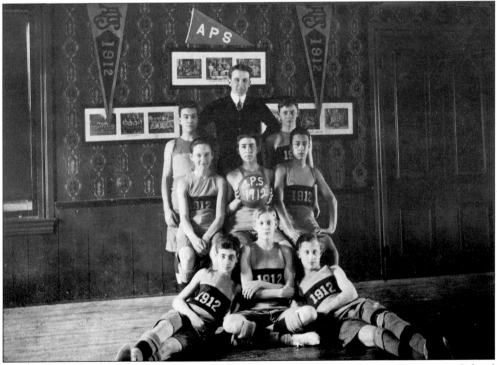

These youngsters constituted the junior basketball team of the Allentown Preparatory School in 1912.

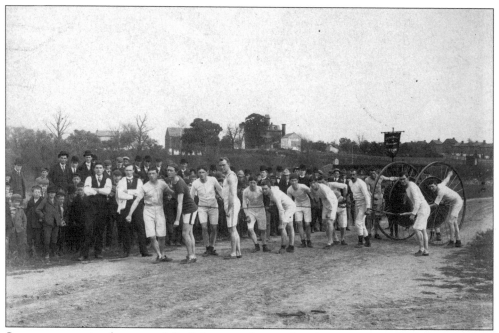

Sports events pitted teams of firefighters against each other in events that demonstrated practical skills. Here, the Hibernia running team is preparing to race while pulling a hose reel. The Hibernia engine house was at 635 Ridge Avenue.

Willie Restum, "Allentown's Good Will Ambassador," began his musical career at Harrison-Morton Junior High School. He played in the band and orchestra at Allentown High School, graduating in 1946. A Muhlenberg graduate, he later played with the Matt Gillespie Orchestra and became a nationally famous entertainer and recording artist, playing jazz saxophone and performing in his own night club. He now lives in Los Angeles and visits his hometown of Allentown from time to time.

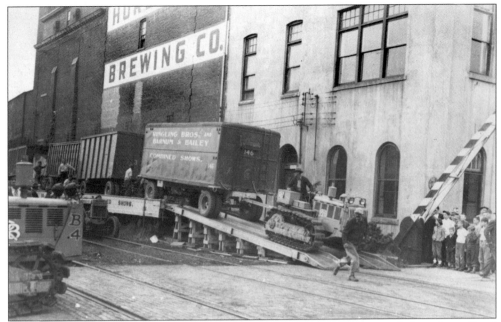

When the circus came to town, children would skip school to watch the parade from the railhead or to watch the big tent being erected. The circus would arrive by rail, its vans and equipment carried on flatbed cars. In this picture, a van from the Ringling Brothers and Barnum & Bailey Circus is being unloaded at Third and Union Streets, near the Horlacher Brewing Company.

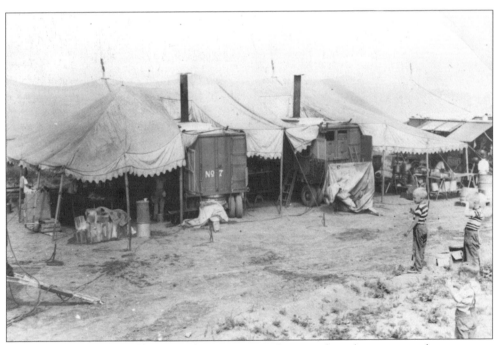

Fascinated children would come to the circus grounds to watch as the tent city of amusements was erected. This is the "back lot" of the Ringling Brothers circus.

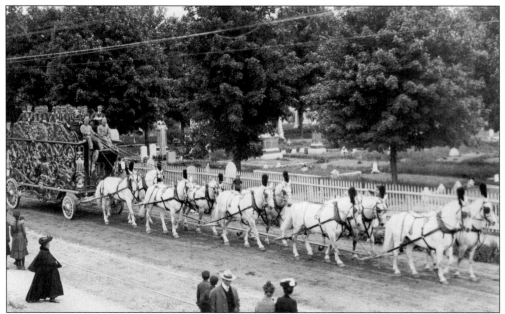

A different circus would come each year. It could be Ringling Brothers and Barnum & Bailey, Sells-Floto, Hagenbeck-Wallace, or another one. The circus troupe would take over the fairgrounds or an open field on Irving Street near Dieruff High School. This parade in the early 20th century is heading for the fairgrounds.

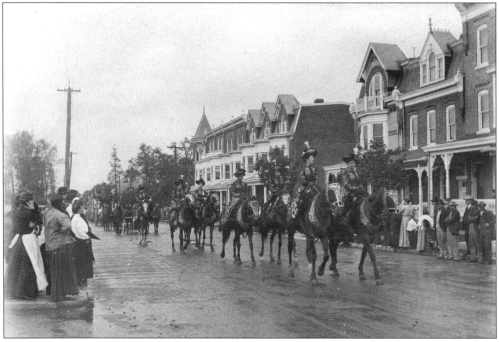

Before a circus arrived in town, notices had been posted and everyone knew it was coming. The circus parade from the railhead to the circus grounds was a huge publicity event, a source of great enjoyment along the route of the parade, and a guarantee that the shows would be well attended. This scene is on Chew Street, east of the fairgrounds.

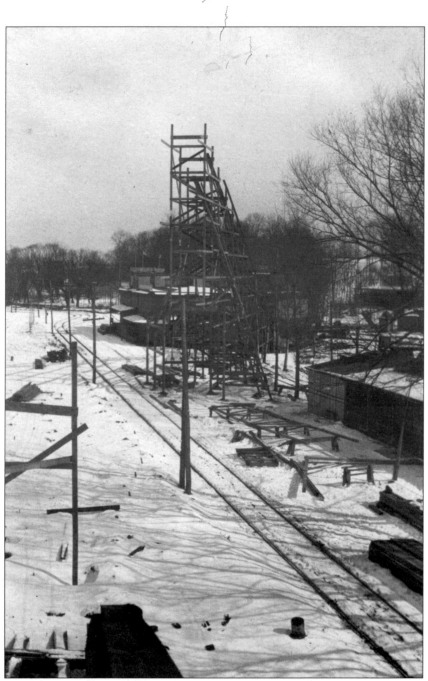

There were two amusement parks developed by trolley companies in the Allentown area. One was in Rittersville, on the road to West Bethlehem; the other was set along the Cedar Creek, near what was then called the Lehigh County Almshouse, now known as Cedarbrook. Dorney Park began as a wooded picnic and recreation area in 1884. The Dorney family added a few amusements and, in 1901, sold the park to the Allentown and Reading Traction Company. The trolley stop in Center Square had a sign for the Dorney Park trolley, and in 1903 the line from the square to the park was double-tracked. The tracks for the traction company can be seen here running alongside the roller coaster, which is under construction in 1923.

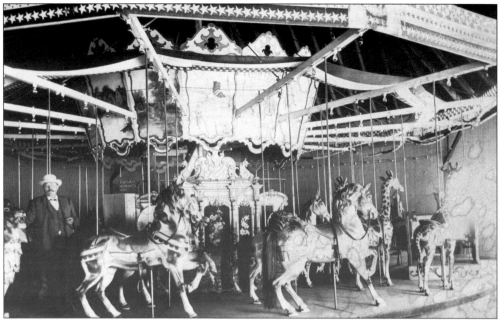

Jacob Plarr, who managed the park for the trolley company, brought this Dentzel merry-go-round and the Whip to the park. Jake Plarr is standing on the left. The traction company sold the park c. 1925, and it was then operated by members of the Plarr and Ott families.

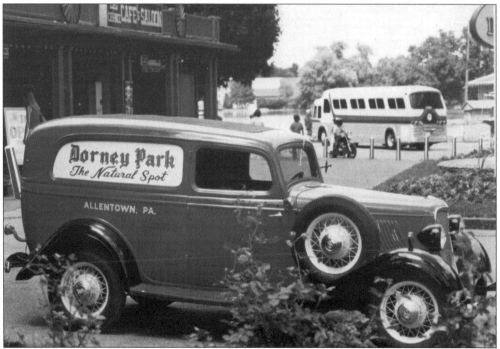

Dorney Park's 1933 Ford V-8 is parked in front of the Dorney Park Hotel. Although the traction company had sold the park by then, and increasing numbers of cars and buses were bringing patrons, the trolley company continued to serve the park until 1936, two years longer than it retained rail service on its other routes.

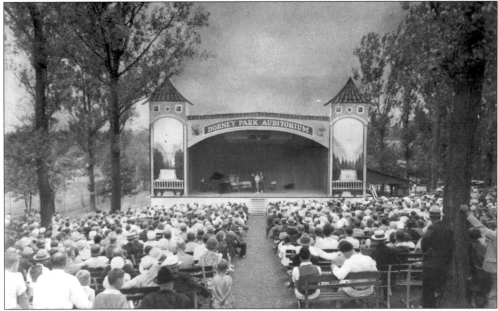

The Dorney Park Auditorium was an open-air theater, shown c. 1935, that featured free movies and shows. This was at the time when there was no entrance fee for the park.

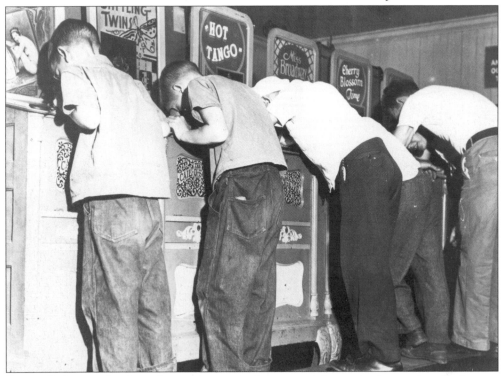

Dorney Park was a family park, catering to picnic groups and organizations such as businesses, churches, and scouts. Report Card Day, when the park was opened for an afternoon to those with good report cards, was a big event for local students. Boys invariably left the group with which they had come so they could fritter away their pocketfuls of coins in the arcade.

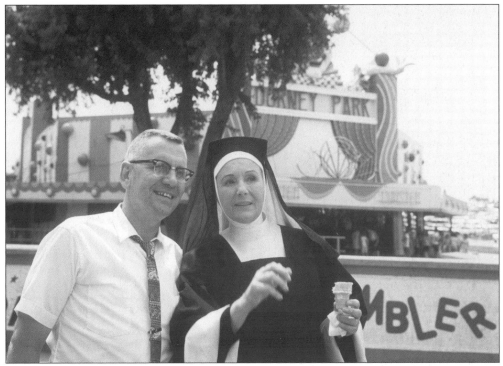

On one very exciting and unforgettable day in 1966, Rosalind Russel, Binnie Barnes, Hayley Mills, and others filmed scenes for *The Trouble with Angels* at Dorney Park. The crew set up one day, and the following day the filming was done. Seen here is Bob Ott with Binnie Barnes (Sister Celestine). Below are cast and crew members with a few onlookers. The Chanticleer ride is in the background.

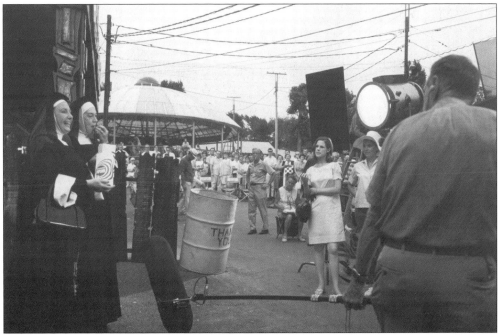

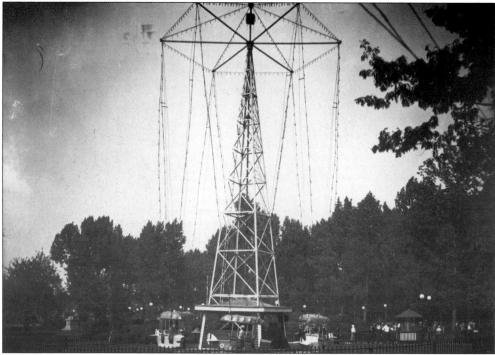

Central Park, originally Rittersville Park, was developed by the Allentown and Bethlehem Rapid Transit Company on a 40-acre tract in Rittersville, between Allentown and Bethlehem. When it opened in 1892, it was a wooded area with picnic groves, walking paths, a few amusements, theaters, and food stands. The first rides were a carousel, a toboggan chute, and the "Razzle-Dazzle." This and the following two photographs are printed from early glass-plate negatives that date from when the park was very young.

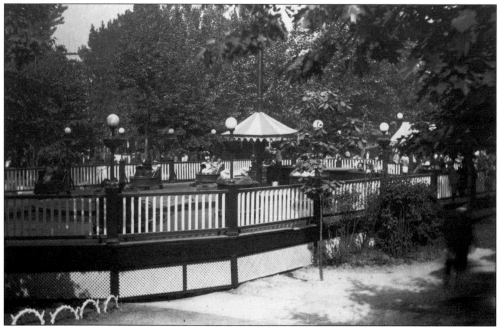

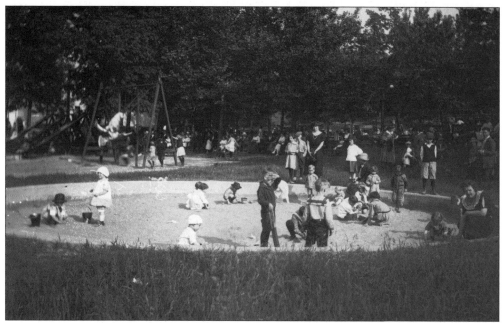

Family reunions and picnics for businesses, clubs, and churches were frequently held at Central Park. This large sandbox provided enjoyment for the youngest family members while their older siblings played on the swings and explored the rides. Among the annual events held in the park was the Baby Parade.

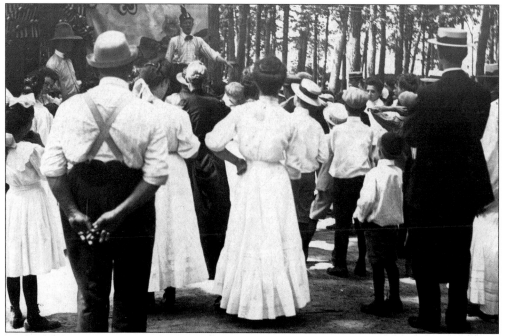

Among the attractions at Central Park were traveling entertainers suitable for family audiences. Theater acts became such popular attractions that, in 1906, the transit company built a theater to accommodate 1,500 people and invited major musical entertainers such as John Philip Sousa's band and a repertory theater group that presented Broadway shows.

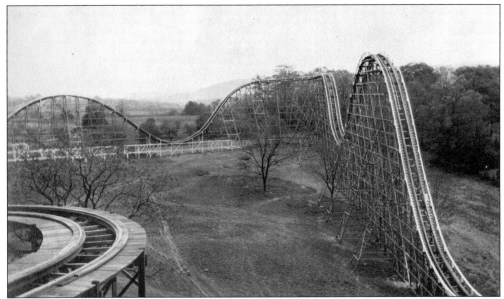

The Skyclone roller coaster at Central Park was built in 1927 but burned in 1935. It was rebuilt but was destroyed again in 1944 in another of the fires that plagued the park. The Lehigh Valley Transit Company sold the park in 1946 after having leased it to a private operator for about 10 years. The park closed in 1950.

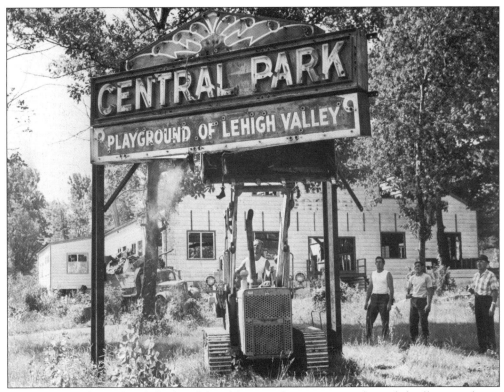

In 1964, the park was demolished, and the old sign at the entrance to the park finally came down.

Six

SEEN AROUND TOWN

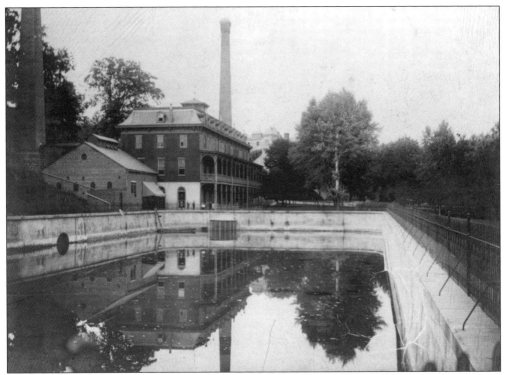

The renown of Allentown's freshwater springs was widespread. Crystal Spring, at the Fountain House resort hotel on Lawrence Street (now Martin Luther King Jr. Drive), was purchased in 1887 by the city, along with the hotel itself, for the new waterworks. Large steam boilers and pumps were installed and a tall standpipe built to provide water pressure. The facility was razed when the present waterworks were completed nearby in 1929.

On these trucks, parked at the northeast corner of Tenth and Liberty Streets, are the letters USAAS. The U.S. Army Ambulance Service trained at the Allentown Fairgrounds from June 1917 until 1918. The young men were known as USAACs. Many of them were sons of wealthy families, and they charmed the town. They lived in sanitized poultry and livestock sheds at the fairgrounds initially, until several large two-story barracks were completed. Their training involved learning how to drive and maintain ambulances so that they could transport wounded soldiers to field hospitals quickly and over rough terrain. Many of them were college athletes, and when they were not engaged in the intensive training to become ambulance drivers, they participated in sports of all kinds. Invitations to parties to meet the young women of middle-class Allentown were frequent.

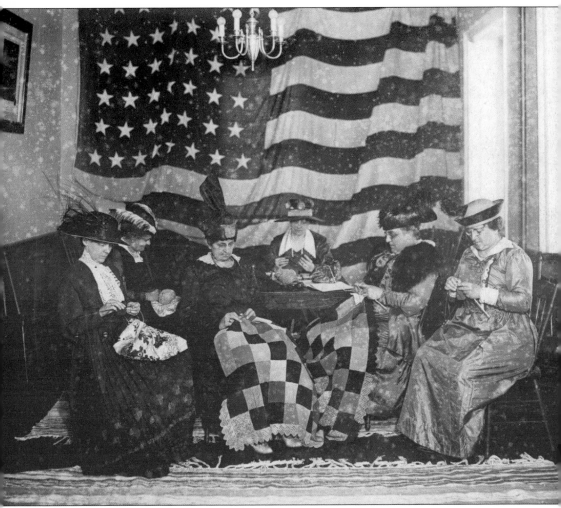

On April 8, 1918, several members of the Daughters of the American Revolution held a knitting party in the assembly room at Trout Hall. Pictured here are, from left to right, Mrs. S.B. Costenbader, Mrs. J.B. Lessig, Mrs. W.B. Grosh, Miss Anna V. Kline, Mrs. C.C. Kaiser, and Mrs. Winter L. Wilson. This kind of activity was sponsored by the Allentown Chapter of the Red Cross, which was organized on April 27, 1917, soon after the United States entered World War I. Knitting consumed much of the time of the middle- and upper-class women of Allentown, who would carry their knitting with them to every social event. Making sweaters, socks, and mufflers was one way to support the troops. Members of the Red Cross also raised money and prepared bandages.

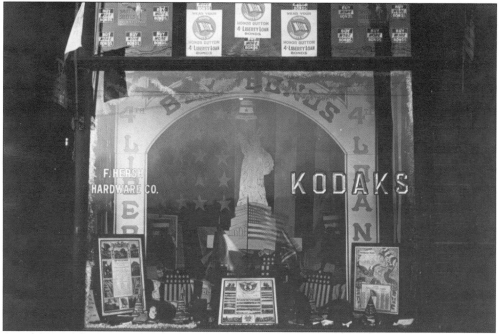

Pressure to buy bonds was intense during the third and fourth Liberty Loan drives held in the spring and the fall of 1918. The patriotic displays in the window of Hersh Hardware, 825–827 Hamilton Street, featured the names of Lehigh County youth and depictions of battlefields in France. This display was made by the Allentown Sign Company.

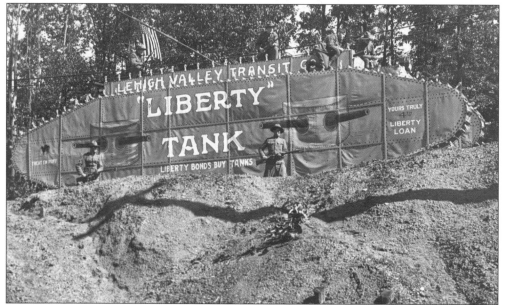

Lehigh Valley Transit's "Liberty Tank", constructed in the Lehigh Valley Transit carpenter shops, was a wood-and-canvas structure built upon a trolley car undercarriage. It joined in all the parades for the Fourth Liberty Loan in the company's service area. This staged photograph was intended to represent a tank in the battlefield trenches. The drive met its goal, raising more than $7.75 million in Lehigh County in three weeks.

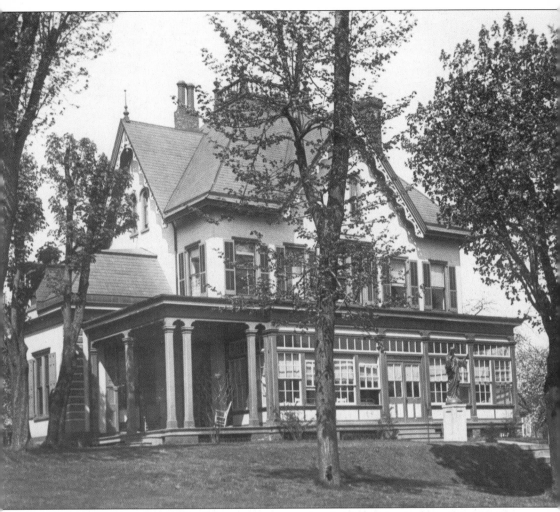

In 1912, when Allentown suffered from a serious outbreak of diphtheria, the city's existing medical facilities were overwhelmed. Five missionary sisters of the Most Sacred Heart came to Allentown from Reading to help in the crisis. They lived and worked in the former rectory at 415–417 Pine Street. The need for medical care for the large population in the First and Sixth Wards had become obvious to Msgr. Peter Masson, the rector of Sacred Heart parish. Masson arranged for the estate of Judge Edward Harvey, at Fourth and Chew Streets, to be bought in late 1913 for the new Sacred Heart Hospital. The sisters remained to form the core of the hospital. Harvey's converted home is seen here in 1915, when it opened with 33 beds, an operating room, and 11 nursing sisters.

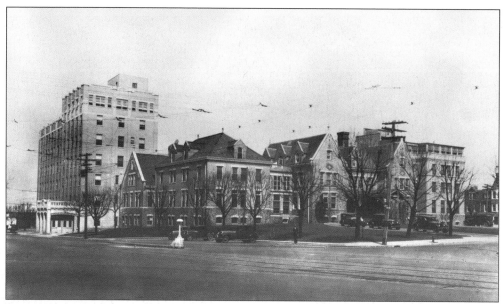

Part of the original 30-bed hospital building is on the right in this early picture of Allentown Hospital. The hospital opened in 1899 at Seventeenth and Chew Streets, on the very edge of town at the time. It was the first public hospital in the city and represented a major change in treatment of ill people. Heretofore, hospitals had been used by the poor who could not afford private care, but this was designed to be a state-of-the-art community hospital.

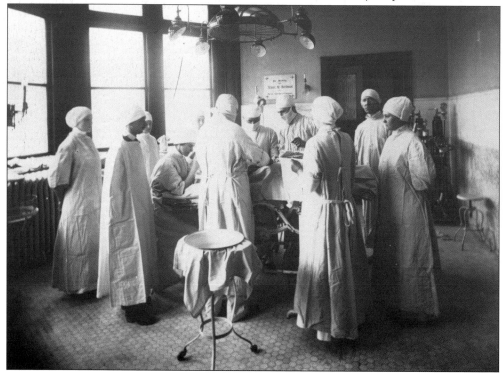

When the Allentown Hospital opened, it had only one operating room. Within very few years, additional wings were added, and expansions were ongoing throughout the 20th century.

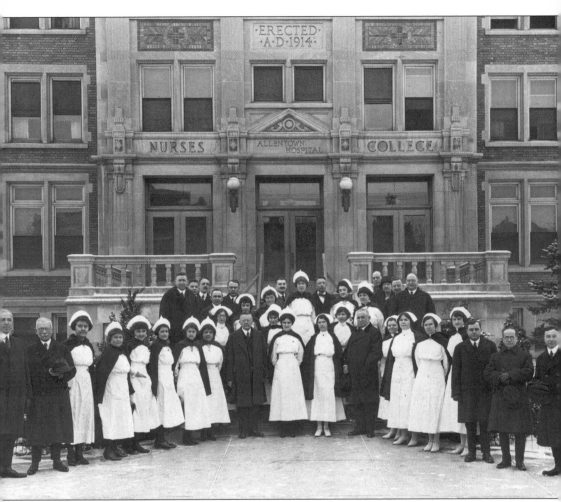

On the southeast corner of Seventeenth and Chew Streets, across from the Allentown Hospital, the Edward Harvey Memorial Nurses Home was built in 1914. It was dedicated to Judge Harvey, Lehigh County's judge of common pleas, whose large estate on Fourth Street was purchased one year later for Sacred Heart Hospital. One of the three visits to Allentown by Pres. William Howard Taft was to attend the dedication of the nurses' college on December 23, 1915.

Pictured here are the girls who attended Miss A.E. Reichard's Grammar School in the Second Ward in 1866. From left to right are the following: (front row, on floor) Elizabeth Bachman, Ellen Creitz, and Annie Strassburger; (middle row, sitting) Lilly Weidner, Lavinia Busse (age 13, in checkered dress), and Mary Apple; (back row, standing) Annie Hersh, unidentified (possibly Reichard), Clara Hartman, and Annie Washburn. Lavinia Busse later became the wife of Charles Nadig, a pioneer of automotive engineering.

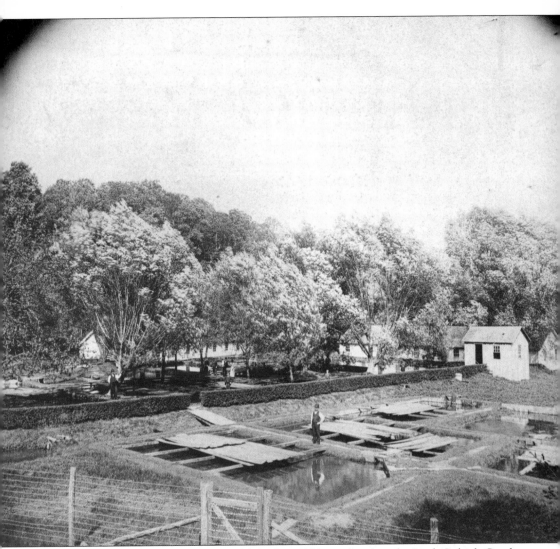

The Little Lehigh trout hatchery was established in 1883 at a bend in the Little Lehigh Creek where large springs enter the waterway. It was leased by the state for 20 years. Note the removable covers over some of the ponds, which were to protect the young fish from predatory birds such as kingfishers and herons. John Creveling built the first ponds for owner Reuben Troxell and still worked there when Harry Trexler bought the trout hatchery in 1907. Trexler ran the hatchery as a fish farm, making substantial improvements. In 1949, the City of Allentown acquired the property. This photograph was made by the Keystone View Company of Allentown (not to be confused with the stereo view company of the same name), which was active from 1890 to 1894 and located at 629 Hamilton Street. The owner of the company, Freeman L. Landon, employed a number of photographers who traveled the countryside. Most of the photographs they took were "homesteads," making this view of the fish hatchery unusual.

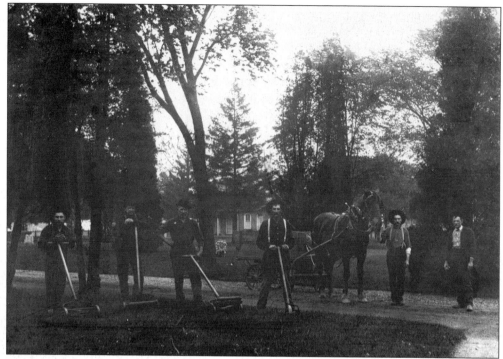

These men are the grounds keepers at Fairview Cemetery, where many of Allentown's prominent people are buried.

The children of city engineer Harry Bascom are shown standing on drilling equipment in their backyard at 1342 Walnut Street, with their attentive nanny nearby. A new well was being dug in July 1916.

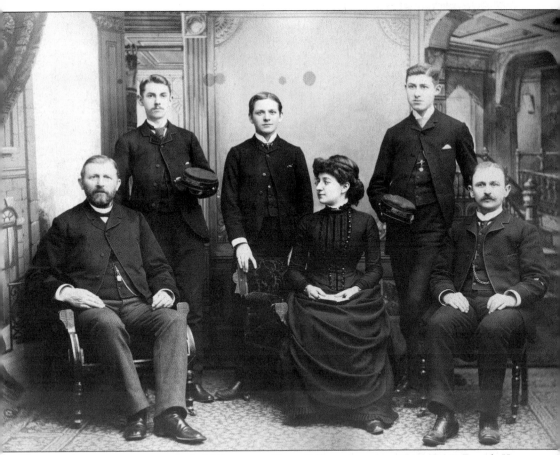

This studio portrait is marked "Allentown Post Office, January 12, 1876." David K. Diefenderfer (on the far left) was the postmaster, Frank L. Good was the chief clerk, Edward Wilt was the delivery clerk, and George S. Kline was the distributing clerk. Diefenderfer was the second postmaster to receive a presidential appointment to the position. He served two terms, from April 1, 1869, to January 8, 1877. During Diefenderfer's tenure, the post office was at 710–712 Hamilton Street but moved regularly depending on the location chosen by each new postmaster. The first public post office building in Allentown, at Sixth and Turner Streets, was not opened until 1907.

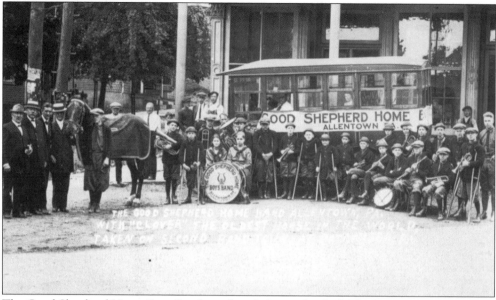

The Good Shepherd Home Boys Band was founded in early 1915. The horse pictured with the band is Clover, who died at the age of 53 in 1924. Good Shepherd Home was founded in 1908 by Rev. John H. Raker, who recognized the need for an orphans' home for children who were crippled or blind. Raker toured with the children in an old van, and they would perform at a number of stops each day to attract crowds to hear Raker's appeals for money.

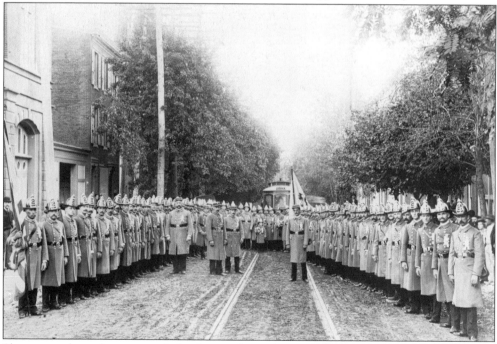

Shown are the volunteers, and the few paid members, of the American Hose Company—Allentown's Fire Company No. 2—which was organized in 1864. The fire house was originally at 16 South Sixth Street and then moved to 624–626 Linden Street. A grand 50th anniversary celebration was held in 1914. The Walnut Street trolley is behind the men.

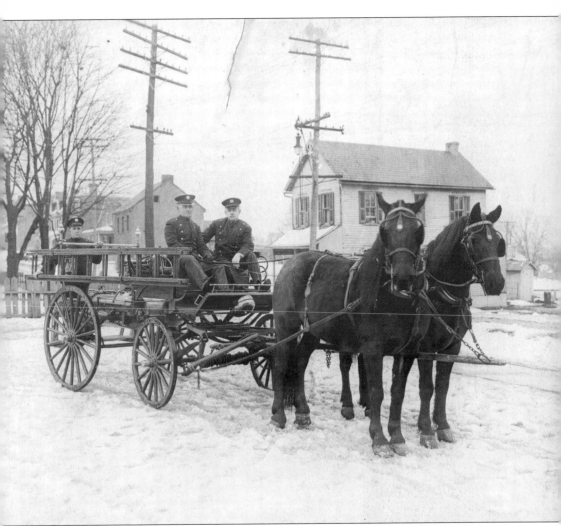

The fire companies in Allentown had to acquire their own horses and provide for their care, although their equipment was often subsidized by the city government. With the exception of the pipeman, the engineer, the driver, and a reliefman, each of the 11 fire companies of the early 20th century depended on unpaid volunteers to fight fires.

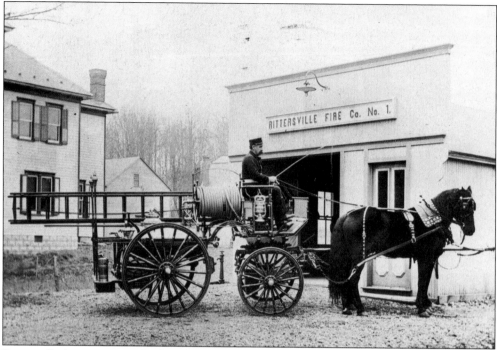

Rittersville became part of Allentown in 1920 when the Fifteenth Ward was annexed. The Rittersville Fire Company became part of the Allentown Fire Department that year.

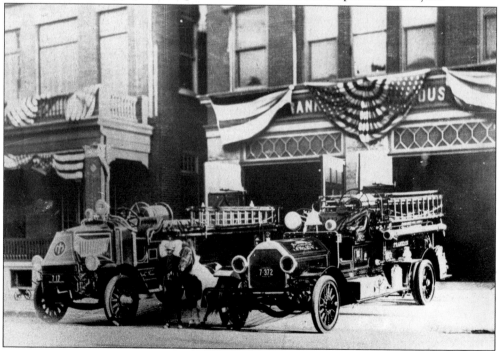

The Franklin Fire Company had splendid quarters at the southeast corner of Fourteenth and Turner Streets. This company, No. 10 in the Allentown Fire Department, was founded in 1900 and had a large membership.

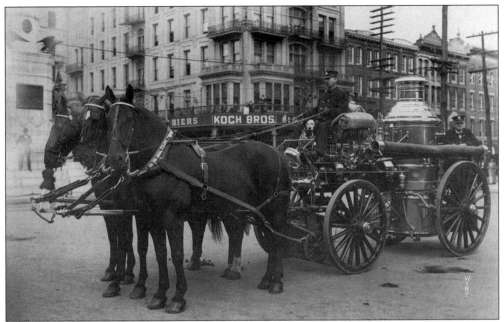

Horse-drawn apparatus proved to be a problem where streets had been paved, as the horses tended to slip while they were racing around corners and speed was essential in putting out fires. This splendid steam pumper is standing with two of its crew and its mascot in Center Square in the early 20th century.

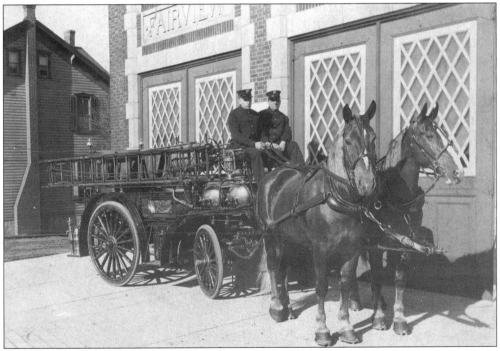

The Fairview Fire Company was organized in 1903 and formally named in 1904. The company bought premises at 1012 South Sixth Street. In 1911, the city provided the firefighters with this fine two-story brick building at 929 South Seventh Street.

BIBLIOGRAPHY

Bartholomew, Craig L., and Lance E. Metz. *The Anthracite Iron Industry of the Lehigh Valley.* Easton, Pennsylvania: Center for Canal History and Technology, 1988.

Beck, Bill. *PP&L: 75 Years of Powering the Future.* Allentown, Pennsylvania: Pennsylvania Power and Light Company, 1995.

Cowen, Dick. *Papa Raker's Dream.* Allentown, Pennsylvania: the Good Shepherd Home, 1988.

Hellerich, Mahlon H., et al. *Allentown 1762–1987: A 225 Year History.* Allentown, Pennsylvania: Lehigh County Historical Society, 1987.

Kulp, Randolph L., ed. *History of the Lehigh Valley Transit Company.* Allentown, Pennsylvania: Lehigh Valley Chapter, National Railway History Society, 1966.

———. *Short Trolley Routes in the Lehigh River Valley.* Allentown, Pennsylvania: Lehigh Valley Chapter, National Railway History Society, 1967.

Lieberman, Charles. "My Life in Beer." *Proceedings of the Lehigh County Historical Society,* Vol. 42. Allentown, Pennsylvania: Lehigh County Historical Society, 2000.

Mathews, Alfred, and Austin N. Hungerford. *History of the Counties of Lehigh and Carbon, in the Commonwealth of Pennsylvania.* Philadelphia, Pennsylvania: Everts & Richards, 1884.

Past, Present and Future of the City of Allentown, Penna. Allentown, Pennsylvania: Board of Trade, 1886.

Roberts, Charles Rhoads, et al. *History of Lehigh County, Pennsylvania.* Allentown, Pennsylvania: Lehigh County Historical Society, 1914.

Whelan, Frank. *Looking Back.* Allentown, Pennsylvania: the Morning Call, 1998.